G000078871

NOW THAT'S WHAT I CALL NEWPORT

Jan Preece

AMBERLEY

To my late wife Sally.
To Jody, Tori, Lucy, Anna, Gemma, and my son Jan.
To Karen Jones.
To Duncan and my good friend Yoasia.
To my good friends from Baneswell, many of whom are now gone.
Thanks for the memories and the fun.

First published 2019

Amberley Publishing
The Hill, Stroud, Gloucestershire, GL5 4EP
www.amberley-books.com

Copyright © Jan Preece, 2019

The right of Jan Preece to be identified as the Author
of this work has been asserted in accordance with the
Copyrights, Designs and Patents Act 1988.

ISBN 978 1 4456 8649 3 (print)
ISBN 978 1 4456 8650 9 (ebook)

British Library Cataloguing in Publication Data.
A catalogue record for this book is available from the
British Library.

Typesetting by Aura Technology and Software
Services, India. Printed in Great Britain.

CONTENTS

Introduction 4
Saying Goodbye to Old Friends 5
The Estates 16
The Seasons 26
Celebrities Come to Town 51
Some Characters of the '80s 68
Music and Entertainment 74
Town Ghost 92
Acknowledgements 96

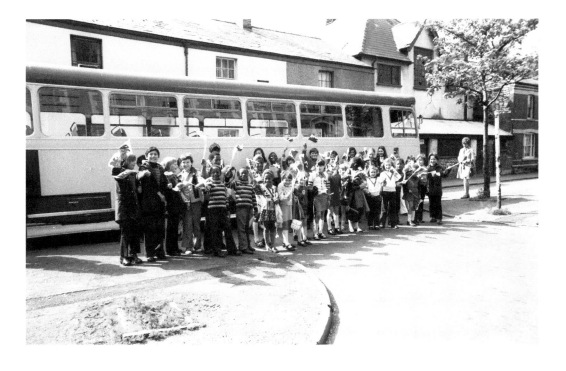

INTRODUCTION

The ancient borough of Newport, the city of Newport, the port of Newport – call it whatever – if it is your home from birth, or you have spent a significant part of your life here, then you will have memories, good or bad, which will become that ultimate touchstone.

The 1960s offered massive cultural changes, a refreshing openness, and a more liberal approach to life. These changes came, not from governments or politicians, but from the streets, generated by a new and inspirational adventure in the world of music and other arts.

While cultural changes swept across the country, changes in the manner in which we lived were fortunately slower to arrive. The terraced street, the factory and the corner shop were still in force, albeit for just one more decade in some cases.

When others eventually decided, on our behalf, to abandon the lifestyles of the previous 200 years, our homes were designated as slums, and our shops became unfit for purpose and were included in local demolitions. Local factories and industries faded from view as the new ways paid little respect to the working man.

Flats on estates, clinical soulless and boring, rose upwards from the green zones that once allowed cattle and sheep to graze and provided a Sunday venue for the picnic and the seeker of open spaces.

Newport has endured decades of what I personally consider to be unnecessary change and turmoil. However, the common theme of self-styled entertainment and community action has always been the focus of the Newportonian. Carnivals, fêtes, home-spun music and theatre, great bands and a willingness to be a part of something old, yet good, still prevail.

In producing this work, I confess that many of my own preferences show through. I hope that those who were also a product of the 1940s will share the belief that the '60s, '70s, and '80s were the good years, rich with memories and experience.

Loving the moment and the characters of yesteryear, loving the town and the personalities of the day, this is a nostalgic look at the period, a work of reference and of pleasure. Now this is what I call Newport!

Jan Preece
June 2018

SAYING GOODBYE TO OLD FRIENDS

In and Around the Town Centre

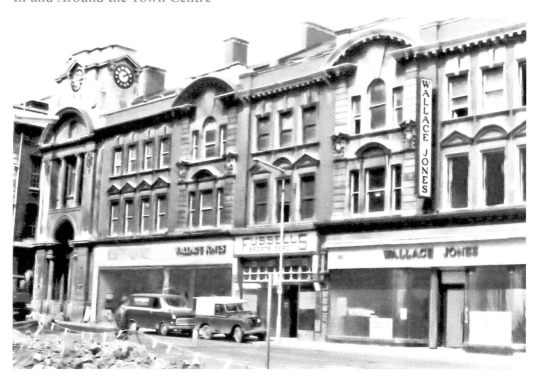

Wallace Jones, Fussell's and the Corn Exchange were much-loved quality shops and buildings, soon to be demolished for road improvements. Few parts of Newport remained unchallenged by the endless programme of regeneration that began in the 1960s and is still in progress. Whole streets have vanished en masse, as have large chunks of famous areas such as Pillgwenlly. Traditionally, Newport was centred around one long street that started at the Alexandra Dock gates and ended at the Norman castle. At the heart of that thoroughfare was a fine shopping area in the form of a Victorian provisions market, which added that extra dimension the townsfolk demanded.

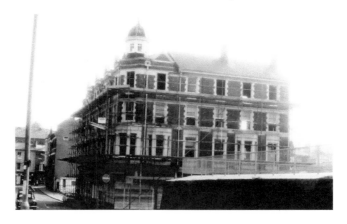

Cambrian Road – or 'Boozers' Row' as I prefer to call it – runs as a parallel to High Street, from Newport station to Baneswell Road. This is where the town's serious drinkers took their apprenticeship. Much of the road was taken by Ansell's brewery. The overpowering and delicious aroma of brewing was ever present. Newport in its day was an extremely sensory town – there were pockets of pongs, some of which were a delight, others like the 'Chem' on Corporation Road were not so good. The whiff of boiling bones to make glues etc. were not pleasant. In addition to Ansell's, the Newport & South Wales Wines and Spirit Company also enjoyed a boozy presence, and was situated next to Newport's throne of thrones, the infamous New Found Out public house. It was Newport's cider house: sawdust floors, sawdust drinkers, and many fights per pint consumed. It was said to cause mayhem among the cider fraternity; all one had to do was throw a pile of pennies through the door and wait for the results. I believe that cider was as little as 9*d* a pint in those far-off halcyon days of the 1960s, which, on reflection, had a massive number of drinking establishments to serve a relatively small population.

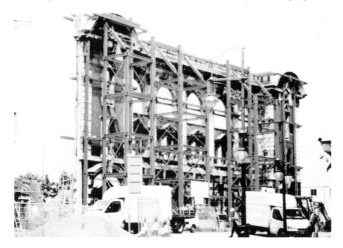

It was a brave undertaking to keep just the front of the old post office building, now looking like a theatrical scenic flat – it wibbled and wobbled until someone put a back to it. It's good to see that our heritage has been considered, but would it not have been easier just to refurbish the whole building?

The breweries have gone in Cambrian Road (*c.* 1981) but the number of pubs and the club remain constant. To the left of the picture was at one time the glorious Princess Tea Rooms, the home of belly-busting feasts loved by all. This is no longer a through road, and access to the railway station is via a subway under the duel carriageway.

A rainy day outside Harpers fruit and veg in Commercial Road. The King's Arms on the right has after many years of dereliction finally been refurbished and has become more flats. Next to it was the Newport Sub Aqua club that became The Top of the Range. There was always a fantastic welcome from Fred and his wife, who made the most delicious spare ribs known to mankind.

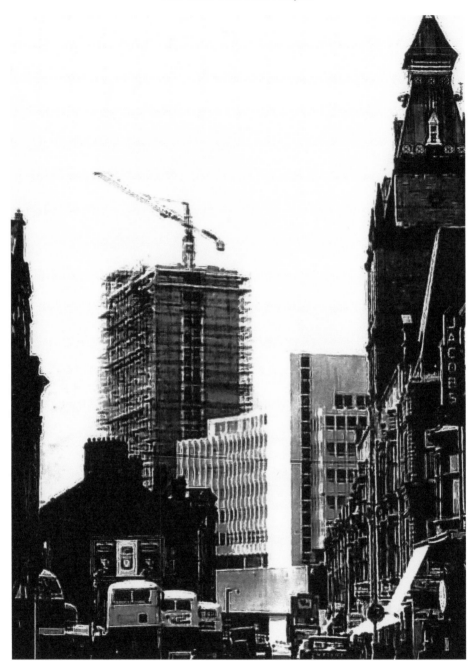

On the opposite end of the long drag is Upper Dock Street, pictured in the 1960s, when the passport office, the first tall building in Newport, appeared on the skyline. This end of block development, at the junction of Skinner Street and Upper Dock Street, ensured that the ABC Cinema would never see 3D arrows again or see Roy Rogers head them off at the pass, at the Saturday morning ABC Minors. Nor would a goodly portion of chips ever see the inside of a crusty cob from the café upon which the tower block now stood.

The Station Inn, Shaftesbury Street, stood opposite the old yard of Robert Wynn & Son Heavy Haulage contractors. A beerhouse belonging to Ansell's brewery became the second office and the first port of call for dozens of Wynn's drivers returning home from three weeks 'up the road'. It was an establishment much lacking in the simplest of commodities and the beer? Well what more can one say. A chemical infusion of tree bark, various green bits and hop remnants, served from the wooden cask, ensured a constant demand for inward purification. It reached the parts that nothing else dared to reach. It was a delight. The smell of floor cleaner, greasy overalls and sweaty donkey jackets created an ambience fit for the royalty of the highways. Suitcases littered the floor. Thick blue smoke shaded the upper torsos of the drinking man and it was said that there were more wide loads moved and gearboxes changed in the Station Inn than there ever was on the road.

The Capitol Cinema, now nearing the final curtain, was pictured here in Dock Street opposite Friars Lane. A large corner building, it can just be seen to the left of picture and was next door to the fire station. This was very much the beating heart of Newport, being just a few yards from the riverbank and its associated commerce. I believe that this atmospheric image was taken in the early 1960s. A wonderful part of the old town, traders had been on the same spot for over 100 years – Embassy and ships chandlers, outfitters to seamen and the route home via the chippy.

Memories of the '60s must include the old Dock Street station and Granville Street and square. Dock Street station gradually lost its appearance as the old Mon line was truncated. The site did stay open for many years as a coal distribution depot. This was the view before the George Street Bridge was built. All that is missing are the horse and carts, and a few sailors perhaps.

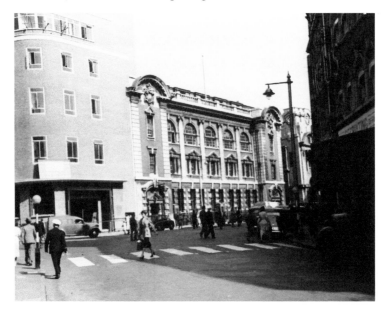

In the days when we had traffic, and people could use shops, and shops welcomed people, in addition to being an imposing piece of architecture, the old post office building was a communication hub. Standing opposite the South Wales Argus offices and print rooms, here one could get the latest editions as they came off the press. News vendors occupied this spot, displaying every newspaper imaginable. There was an abundance of telephone boxes and it was here that a local letter posted first thing would arrive the same day. Progress, who needs it?

Baneswell

Bailey's Bodega was one of the first independent pubs in the town specialising in guest ales and real beer. Baneswell is a community at the heart of the city. Challenged by redevelopment and threatened by a proposed new road that would have destroyed the community, they stood fast in the face of adversity and the district has survived. Steeply graded rows of small terraced houses, it boasted corner shops, pubs and a school. It is unique to see such a concentrated area of dwelling houses so close to the city centre.

The dreaded wheelie bins have arrived. This is St Mary's Street, Baneswell, in the early 1980s. Most of the properties are now sparred or painted. The old render and stone has been covered, and trees now appear in the road. In the 1960s it was affectionately called the Baneswell Triangle.

The Big Top at Shaftsbury Park.

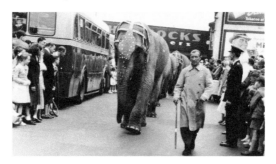

When I think of the big top, I now look at the size of my ageing midriff and wonder if I will ever be the Adonis that somehow passed me by. Yet in the 1960s a mere mention of the Big Top sent shivers of excitement through a young mind eager to enter the wondrous and amazing world of the circus: Billy Smarts, Chipperfield's and Bertram Mills, bellowing elephants, feathered Red Indians, camels and the Human Cannonball flaunt their outrageous skills on the public highway en route to the circus ground, which was of course Shaftesbury Park. The ringmaster, in a vulgar yet beautiful American Chevy, proclaims the forthcoming extravaganza; roll up, roll up, roll up for the greatest show on earth. See the amazing Vertigo Brothers as they defy gravity at 100 feet above the ring. Visit the unbelievable Wolverine sisters, half women half wolf. They've been held in a titanium cage since their capture in the most remote region of the Rocky Mountains.

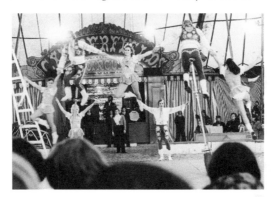

The very aura of the 'over-the-top' propaganda associated with the circus made it a must-see. We watched the parade pass by, sometimes coming by train, but normally a mishmash of almost vintage vehicles, driven between towns by local lorry drivers eager to make a few extra bob by ferrying the roadshow overnight between showgrounds.

Our journey to the show! Lines of eager folk queue patiently for the best seats in the house, the occasional roar of a lion turning heads. Did we want to see a pair of legs hanging out of the beast's mouth? Happily, we never did. Sometimes we crept onto the site to see the Big Top being erected. Inch by inch the great marquee was raised to the tops of the massive poles. Guy ropes and stakes acted as a support mechanism, like a massive pair of corsets.

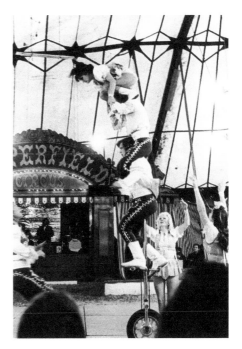

Let the show begin. On the night, we strained necks. The level of pain depended on how much we paid for the seats. Having been wowed, terrified, amazed, thrilled and reduced to uncontrollable mirth by silly men with red noses, we left the ring, for what I considered the very best bit of all. There is no smell like that of a circus menagerie.

The deep straw and the unmistakeable aroma of a frustrated lion swamped the nostrils and sensory system. After this, we, with jaded and fading legs, yomped across the park and through the terraced streets to the bus station, where we happily rested our weary but contented frames on the slated wooden seats of the last No. 9 to the docks. Roll up Roll up, the great bed awaits!

Somerton Park

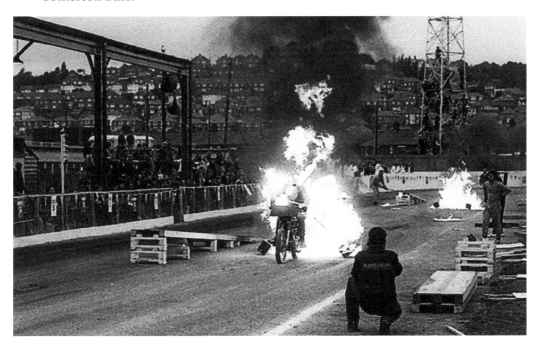

Not all circuses came with a Big Top. In the 1970s at Somerton Park the visitors were the Canadian Motor Circus. Motorbikes through hoops of fire and anything that should have been on four wheels could be seen on two or fewer. Even in the lower division the pitch was special. Supporters never took kindly to cars and bikes racing around the perimeter.

Newport High Street – The Down Mail

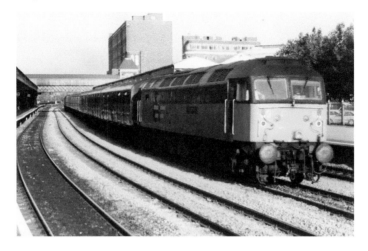

What is it that brings men, young and old, to stand on a windy station platform just to see the mail train pass by? Throughout the week, at around midday, a small crowd gathered, some armed with stopwatches, others with notepads and pencils, with the sole purpose of seeing the Royal Mail travelling post office race non-stop through the station platforms.

The lure of the mail would appear to be almost worldwide. The early Pony Express, the Royal Mail stagecoach, and the travelling post office have all generated an unrivalled following. Was it perhaps because of the wonderful work by W. H. Auden called 'Night Mail', which is so beautifully composed to the gait of the pounding pistons of a steam locomotive? Who knows?

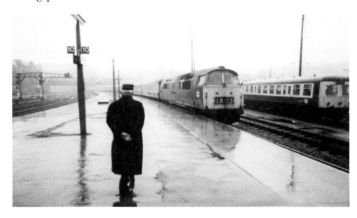

A vestige of the old Great Western Railway when the stationmaster – with his top hat, fob watch and a raised eyebrow – scrutinised every train movement in and out of his station. This was the 1970s 'blue' era when all locomotives were painted in that corporate blue and wore the distinctive logo of two parallel lines on their cab sides. To me it was Newport station as I most remember it: the old goods yard, the carriage sidings, and train guards that carried a flag and whistle. It is just another small thing that screamed out now that's what I call Newport.

Newport Is All About Looking Up

To revisit Newport at its very best is quite easy; just look above the ground floor. Then, the full delights of the Victorian period architecture can be enjoyed. This '70s view of Burton, the tailors, taken from the Westgate Hotel, illustrates the incredibly beautiful bay windows. Known and respected nationally for their quality bespoke suits, they departed from the Newport High Street many years ago, another leak in the stream of excellence that flowed through the town.

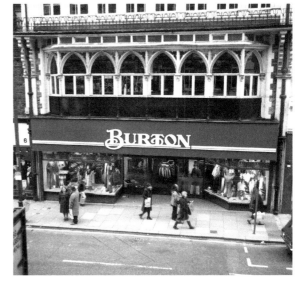

The Newport provision market can only be described as stunning. It has been, for years, the retail home for many of the oldest names in the Newport business community. Fresh fish, meat, groceries and cheeses were all once to be found in this Victorian trading paradise.

In the 1960s the market steps were the obvious meeting place. At the rear were the Mods and their scooters. At the front, which was High Street, one found the rockers and their wonderful bikes – and even some shoppers, would you believe.

Sadly, today it struggles against the might of the supermarkets, but the Newport shoppers are traditionalists and for many decades the weekly shop had to begin at the market, a worthy weekly pilgrimage for the pleasure of seeing and interacting with a human being, a friendly smiling face, and good fresh food.

THE ESTATES

Maesglass

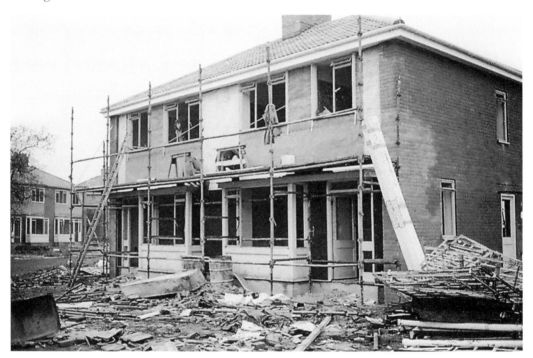

Newport is very much the old and the new with little in the middle. Maindee, Pillgwenlly and Baneswell provided the nucleus for over 200 years. A series of redevelopments and a growing population resulted in a series of new estates in what was then the outskirts of the city being built. Three of them – Maesglass, The Gear, and Somerton – are the oldest.

Maesglass, built in the 1930s of red-brick construction, was next to the huge GWR locomotive sheds. In the late 1970/'80s it underwent a major refurbishment: cladding was added to the exteriors and the insides were modernised.

The Gaer Estate

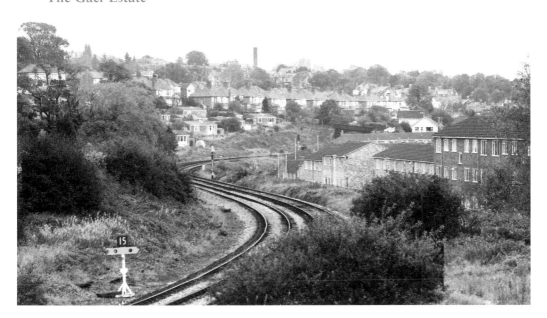

The Gaer, named after the Gaer Hill fort, is a sprawling array of characteristic flat-roof houses layered into the hillside. It looks almost defensive in shape and form, as is the ancient fort on the opposite side of the hill. Anyone born post-1950 will know the Gaer. When it was completed in the late 1950s it was an award-winning development. Surprisingly it has shops and the usual commodities but just one pub, the Gaer Inn. The Gaer climbs from the Western Valley Railway line in layered rows of houses, and near the top it merges with older properties of the 1920s. This 1984 image shows the early prefabs at the very bottom of the estate.

Ringland and Alway

I will probably be hung for this, or at the very least deported, but in 1978 these images of Ringland, Bishton, Liswerry and Alway would, to a stranger, appear as one. Ringland has had a chequered history since it was built, often known for excessive crime and violence. It is not Newport's most salubrious estate. However, it follows a national trend whereupon small numbers make the biggest noise. The clear majority of the Ringland community are decent folk, but they are undermined by the same social maladies that now affect us all.

Treberth is a smaller area tucked in between Ringland and Alway and is mostly adjacent to the main A48. Mr Berkhard, the owner of the filling station, found a very novel way of promoting the Queens Silver Jubilee in 1977. I hope it wasn't full of petrol.

Malpas

Of all the post-war developments, I think Malpas wears the crown. Prior to the huge Bettws complex being constructed in the 1960s, Malpas was a pleasurable outpost, to be enjoyed for its countryside, sandwiched between its meandering railway line and the canal. The image shows the start of Malpas Road, taken from the Barrack Hill section of the canal. It was soon to lose its identity to the inner ring road. In the foreground is the entrance to the James and Emmanuel garage.

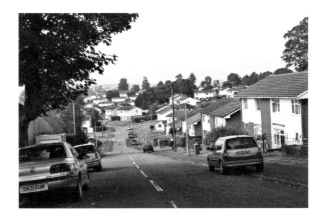

The railway that ran via Courtybella linked Newport Docks and Dock Street goods station to the rest of humanity, which can be called Cwmbran. It closed in the early '60s. As a point of interest, the new duel carriageway that bypasses Malpas is on the trackbed of the railway line. In the late '50s the trains could be heard quite plainly. It is quite distressing to know that just a few short miles down the line that same train would be in our beloved Pill, where we all really wanted to be. Various sections remained until around 1965 when it was finally cut back to the site of the old Dock Street station. The canal, however, remains. During the war years a large American camp spread over the fields and when it eventually closed it left a series of Nissan huts on the top of what is now Whittle Drive. The image of Malpas looking from Westfield shows a distinct lack of change; take away the cars and you have the Malpas of the 1960s. In the distance Twmbarlum, the Tump clearly seen, looks down over Newport. So far away? No, not at all. In the day we would be looking down as well.

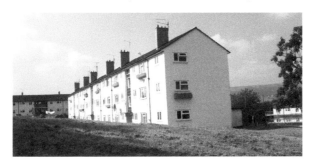

The canal was an adventure playground. As a twelve-year-old I would walk across the fields at barely first light, seeing the silvery thread growing nearer with every step. Armed with my fishing rod made from tank aerials and a pocket full of maggots, I would find my favourite spot and fish until school time – which I frequently forgot! That was a special time, accompanied only by a watching fox who was always to be found in the derelict orchard, crouching in the drystone walls, checking me out – no doubt considering if a small boy was worth eating.

To reach Malpas one caught the No. 3 bus, which ran from Maesglass. It was like a world tour. On reaching the terminus one was met with unfinished roads and builders' huts as the estate was still growing. The last editions were the flats – Jean Close, Hargreaves Drive etc. – which were complete in 1956/58.

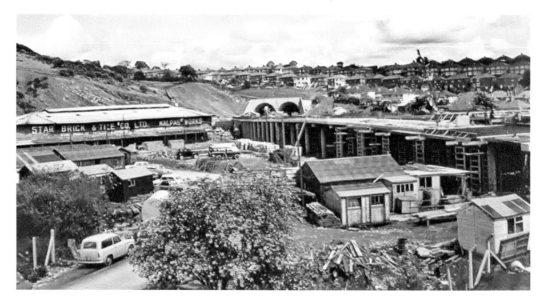

Malpas has incredibly never changed other than cosmetic works and some sheltered housing. Returning after forty years, it was like a time warp. However, this cannot be said about the main road, which in the late 1960s was altered considerably to accommodate the new M4 motorway.

Duffryn

The sprawling Duffryn estate, which was completed in 1978, was like the Gaer, an award-winning design. A perimeter of housing based around a green central area, a large comprehensive school and a variety of other amenities including a major supermarket makes up the community. As with the other areas, many residents came from Pill. The estate was built on ground belonging to the Tredegar House. Duffryn Comprehensive School was also a regular venue for safety cycling and safe driving rallies. Its ample proportions made it a valuable community amenity.

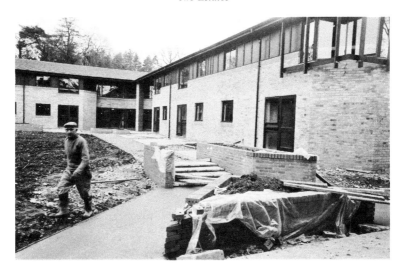

Accommodation for the elderly under construction. This was named Duffryn Woodside, and is quite near to Tredegar House.

Brynglas, the Senior School and Brynglas Hill

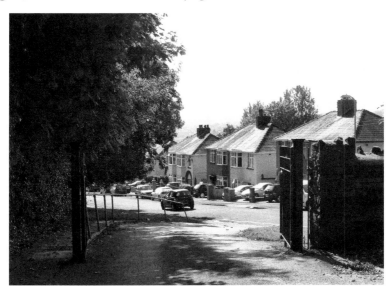

Brynglas sits happily on a hill, as does most of Newport! At the top of the hill also rests Brynglas House, built in 1884, which was the residence of many notable Newport families including the Cordes family (Dos Iron Works) and Mayor James Brown. It was acquired in 1922 by Newport Corporation and became Brynglas Central School.

How many thousands passed through these school gates, to take the long walk down the endless hill to Malpas Road and then home. For those of us living at Malpas, we took the Yewberry Lane route, often stopping to buy a penny apple from the farm, a great sour cooking apple that took an hour to digest and seconds to recycle!

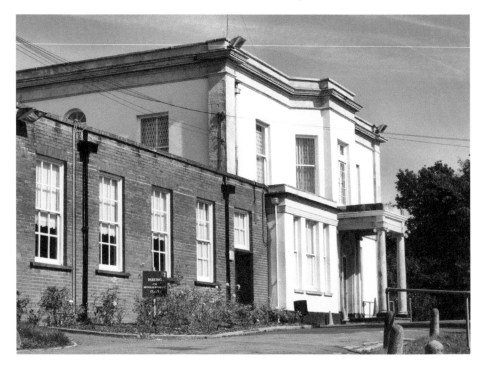

It is a most beautiful building, and too good to be a school. It was on this balcony in 1960 that Mr Carey, the headmaster, in cap and gown with swishing cane and canary-like whistle, would terrorise the latecomers trying desperately to sneak up the school drive. One minute late is all it took for a visit to his study. Hello painful hand, good to have you back again.

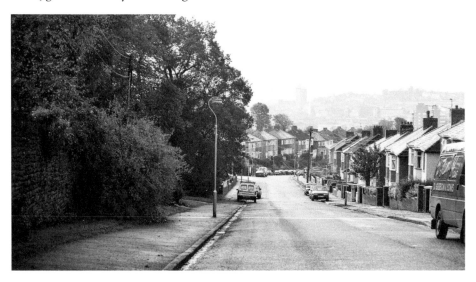

Brynglas Hill. On leaving the school we were under strict orders for boys would walk on the left, girls would walk on the right; Heavens forbid that we should ever look at each other, though a few did – and lived to tell the tale.

Tredegar House and Country Park

Tredegar House is a grand seventeenth-century country house, and the family home of the Morgan's, latterly the Lords Tredegar. Tredegar is a name synonymous to much of Newport; Tredegar Pill, Warf, estates and many other areas of property and land share their name. It became a listed building in the 1950s and was St Joseph's Roman Catholic School for many years prior to becoming a heritage site and country park.

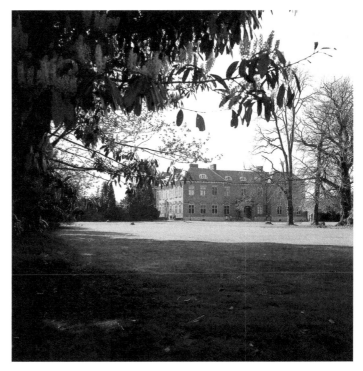

The house, which is now administered by the National Trust, has an impressive lake, which when this was taken in 1974 was open for boating and fishing. Many tales abound regarding the depth of the lake. It is often suggested that it is without end.

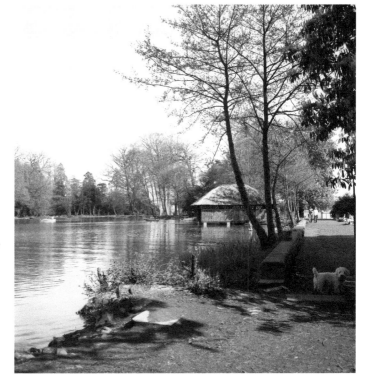

St Joseph's RC School

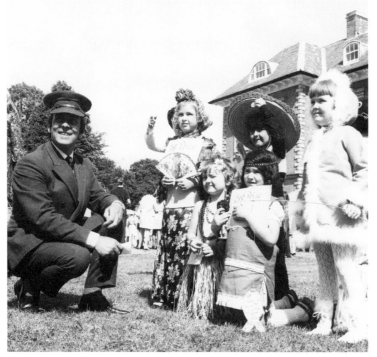

This was one of the last school fêtes as the house was soon to undergo a major refurbishment. A new purpose-built school was under construction virtually on the doorstep, while the house was being prepared for its new role as a country park and heritage venue.

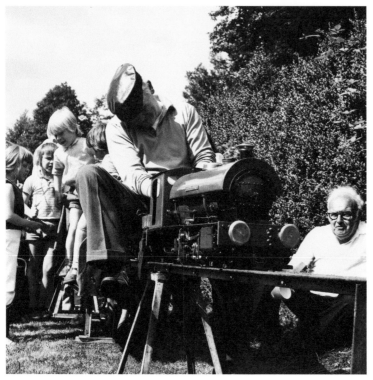

Model engineering was as popular in the day – hardly surprising when considering the incredible industrial heritage of the city – as it is now. Where there was a summer fête, there was a narrow-gauge railway!

Bettws

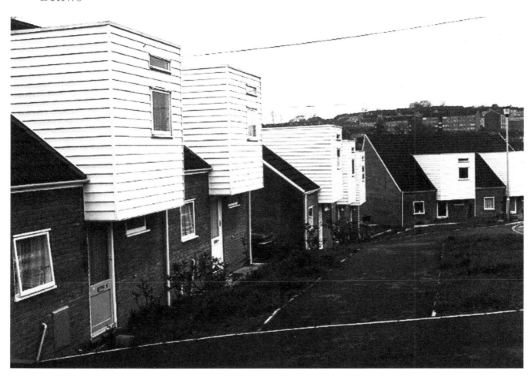

It is claimed that Bettws estate is one of the largest housing estates in Western Europe. Plans to merge Malpas and Bettws were once discussed, but I think it is good that it never happened, as both areas now have an identity of their own. What was once an unobstructed view across open fields to the west of the town, as seen from Malpas, is now a mass of dwelling houses. It is almost a small town. In the late 1970s starter homes were under construction, the first taste of private ownership sharing with social housing perhaps?

One of the better ideas of the day was the construction of the Woodstock and Morgan's ponds at Bettws. Newport had lost one large fishery when the St Julian's pond was filled in, on the site of the old brickworks near Bank Street. The picture shows the ponds shortly after opening. It is much different these days with lush trees and foliage growing on the banks. This is now a very popular fishery with many large specimens taken on a regular basis.

THE SEASONS

The Spring

In the summer, we play with our iPhone, in the autumn we play with our iPhone, and at Christmas we play with our new iPhone. In the spring of the '70s and '80s, as we had done for many previous decades, we walked to the mountaintop. Each Good Friday hundreds walked to Twmbarlum, which are a long range of hills acting as a blue-grey back scene to the city, which at the Newport/Risca end boasted a large boil-like mound, thought to be an Iron Age hill fort. It was called 'The Tump'.

This was the target. Sitting on the mound of gravel and flint, we ate our salad cream sandwiches and took our water from the empty pop bottle, and looked out in awe across the Bristol Channel to Avonmouth, Portishead and Bristol.

In the afternoon numerous trails of smoke appeared on the horizon and the distant sound of fire engines rang out en route to tackle the numerous gorse fires caused by overenthusiastic boy scouts and walkers and their camp fires.

In the crispy clear waters, refreshed by the melting snow, we enjoyed the first trappings of spring, writing our names with a stick in the lapping rivulets fed from the hilltops. It lasted just microseconds but that wasn't important as the gesture had been made and the annual pilgrimage to the ancient hilltop was fulfilled.

Summer

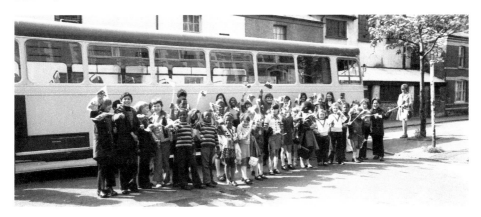

Sugar cane sticks for the kids, light ale for the men, crated and left in the luggage department for the journey home. Eggy wafts caused disconcerting looks as the shopping bags were filled with egg and cress, ham and cucumber and the thermos flask. Once more into the breach flask, it's your time again. Sugary sweet tea with sterilised milk; the one from the tall bottle with the crimped metal top.

All that remains is the charabanc and if it doesn't come? It always did. In the day, the streets had their own outings. It was more structured in the 1970s as the corporation single decker arrived at a central point, for the group that comprised mostly of children. Nevertheless, the traditions of a trip to Barry Island or Porthcawl continued, as did the anticipation and the excitement of a day in the land of candy floss, chips and the wonderful fairground.

An excuse is never needed for a good old knees-up in the street. It was quite common in days past to drag the piano onto the pavement and crack open a bottle! Here in 1974, summer street parties preceded the Pill Festival, and the ladies wasted no time in filling the table with party grub.

Summer Parades and Festivals

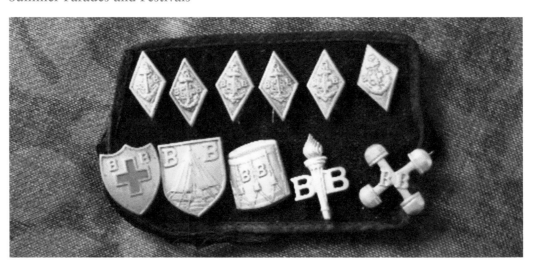

The sound of a good bass drum is more than enough to get any man rushing to the cupboard for his pith Helmut and bayonet. It is the special noise of the bugle and drum band, the noise that you feel inside, that raises the hairs on the back of the neck and stirs the spirit. Horripilation, I believe it's called. I prefer to say goose pimples.

In the 1960s and indeed the '70s, Newport was enriched by many youth organisations: the Scouts, Boys Brigade, Sea Scouts, Guides, Brownies, St John's Ambulance brigade and many more. Each parade had a meaningful origin. Mayor's Day, Remembrance Sunday, Founder's Days, the annual youth parade and of course the religious festivals, of which one, Whit Sunday, always stands out – new clothes and the promise of a Whitson field treat on the 'Field'.

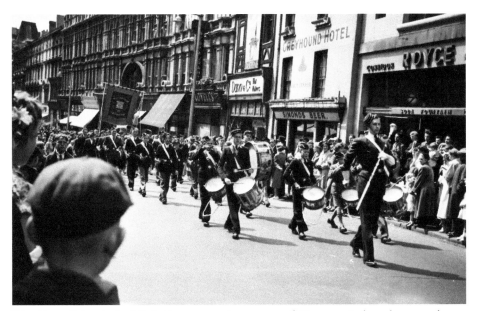

The Boys Brigade in High Street, passing some of Newport's best-known shops. Parents took an interest and turned out en masse to support the boys and those who marched. As a band player – drums and bugle – there was the added incentive to clean and polish both one's self, our instruments and, of course, our uniform. Attainment badges were gathered by the year of service and rank. Today, the concept will no doubt be met with the two fingers down the throat gesture. It was about pride. We as young people had loads of it, irrespective of our backgrounds. Competition was always healthy but fierce. Who had the best band? We in the Boys Brigade obviously claimed the throne but I must confess, I think the Sea Scouts had the edge on us all. Sorry chaps.

Another parade another festival. The late Morris Wight, of Wight sound music, leads the Scout Band into the YMCA grounds at Pill. 'Mo' was a much-loved figure – one could say Newport's answer to the great Brian Epstein. His musical emporium fed the many bands of the '60s and '70s with instruments, gigs and advice.

As a young and often impoverished drummer, I, on occasion, borrowed some extra kit from Mo, who would get us our Saturday gig. When Monday arrived and the drum was returned he would pay us out. The depleted amount dropped into my twitching palms and would often cause a raised eyebrow. 'Well it's like this our kid, I had to keep back ten bobs for the loan of the drum.' We all loved Mo, who was a real character of the town.

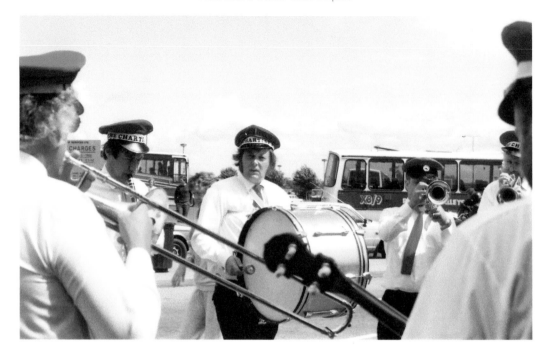

Marching bands of a different kind. In the 1980s a new band was formed: the Chartists Marching Jazz Band. It comprised of jazz musicians and performed live New Orleans-style jazz to venues in and around the town. Those who are familiar with the Bond Film *Live and Let Die* would appreciate the Chartists. Funerals were a speciality.

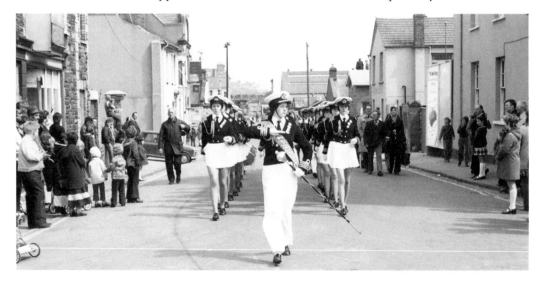

Parades and carnivals were an accepted part of the summer season. One of the early major events was the Royal Gwent Hospital Fête, which was followed by the Newport Carnival, and in 1974 the Pill Carnival began thanks to the efforts of George Bullock and his group. Baneswell ran their own event, as did Maindee. There was, of course, Corpus Christi parades but these were in the earlier years.

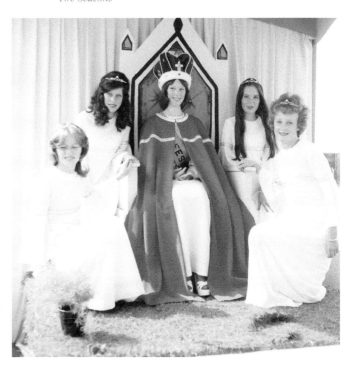

The Carnival Queen was the principle float in the Pill Festival. However, events began with a church service in which the principle churches joined together for the event. The Pill Festival was a welcome relief as it began during the redevelopment years, when the area in which it was held was disappearing by the day. It was an unforgettable exercise in community regeneration.

Knees-up Mother Brown

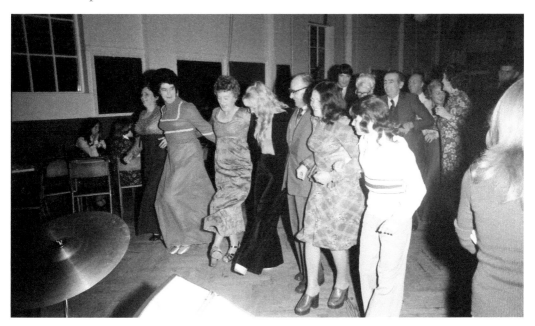

Disco time at St Michael's. The work of the carnival committee was an ongoing process, generating funds and community action, and it was also an excuse for folk to forget the bulldozer parked at the end of their street, and get on doing that which they did best – have fun.

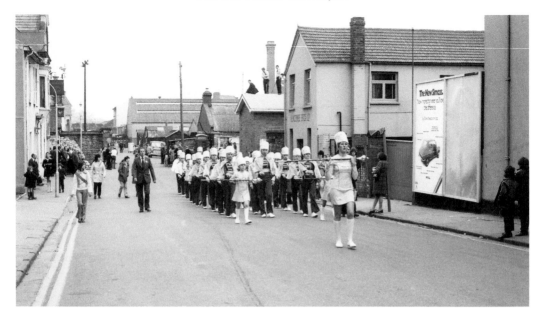

In the 1970s many parades started in the cattle market. This parade was the jazz band competition, which was held annually in support of the carnival. Newport had many parades and it demonstrated commitment, walking for a mile or more in the pouring rain.

Bless This House

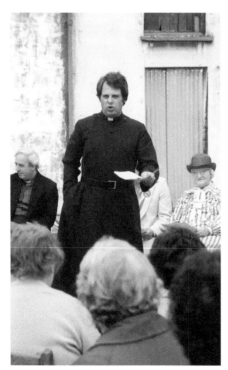

Bless this house, the one with the corrugated iron over the door. Revd Brian Stairs holds an open-air service among the boarded-up homes awaiting demolition. Revd Stairs was the vicar at St Stephen's, which was one of the Anglican churches.

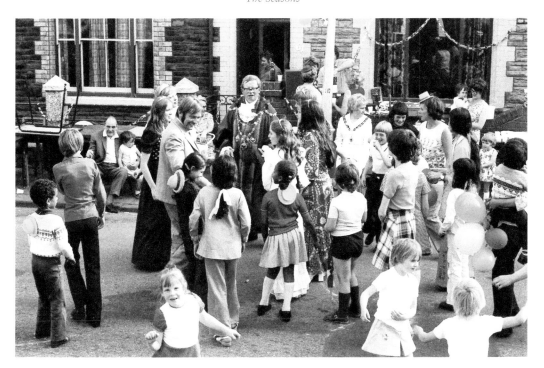

The 1974 festival was a huge success for a new venture, and streets parties were held throughout. Here in Capel Crescent, the current mayor, Councillor John Marsh, spent time among those celebrating. George Bullock was the man at the helm and accompanied the mayor throughout the day.

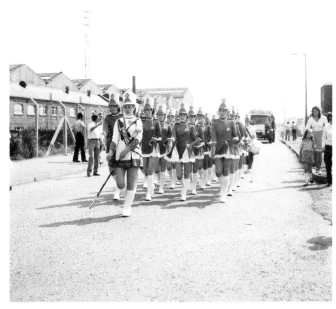

The carnival parade was the main event, a let-the hair-down moment among the many packed streets and pubs, which were still open at that time.

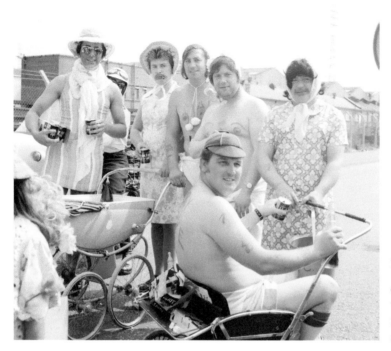

A bit late for the beautiful baby competition, though he is wearing a school cap.

The fairground has always played a part in the festival. Firstly the parade and then to the field for all the fun of the fair, not forgetting a pint of the good stuff en route.

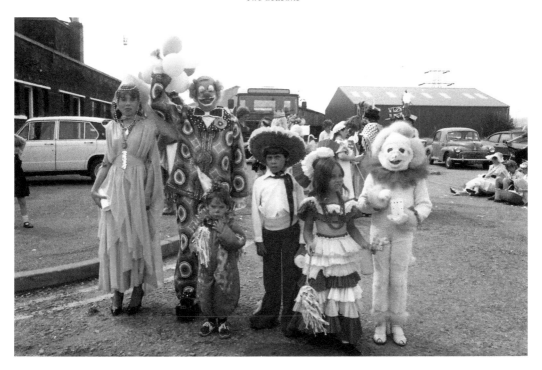

Who said clowns were scary? Whole families walked in fancy dress from the starting point in the Alexandra Docks to the field, nearly a 2-mile walk. I bet he was scary when the blisters appeared.

The Baneswell Festival

The Baneswell Festival was smaller with fewer floats and had the disadvantage of many hills to climb. Baneswell is built on a steep gradient with some narrow streets, making it difficult for the traditional carnival float. However, the enthusiasm was as great as any other of the carnival events.

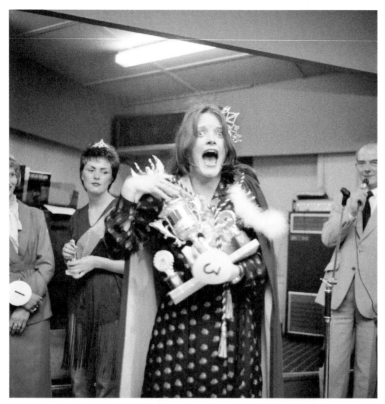

As part of their festival week Baneswell held a Beautiful Baby Competition – not an enviable task for the judges. 'Best-looking babies line up here, as for the rest please come again next year'. Who on this earth is brave enough to suggest that someone's child is less than perfect? It's a good job the children of Baneswell are all beautiful.

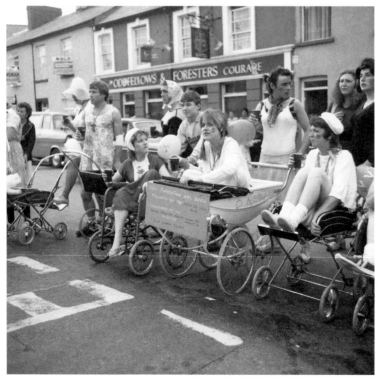

The Baneswell Pram Race, where perhaps a mountain guide would be more appropriate. About to attack the hills, the contestants line-up, having refuelled at the Oddfellow's and Foresters.

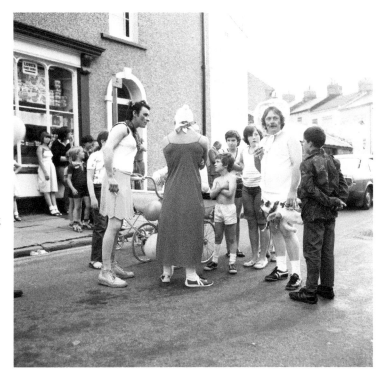

Is this a tactic being discussed or who is paying for the next round? Baneswell probably had the best pubs in town, which made the pram race more pleasure than purgatory.

It's a Tug of War

Hardly a tug of love as battling pub teams take on all comers in the Baneswell Festival tug of war. This site at the top of North Street is now taken by a doctor's surgery. In the rear is the imposing façade of St Woolos School. It is a fine Victorian red-brick building that still stands today.

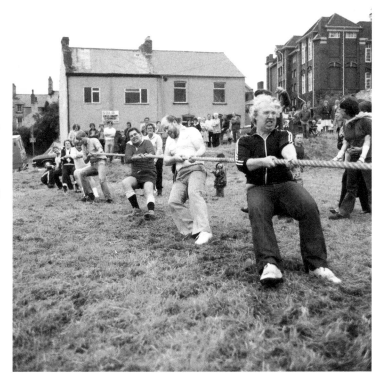

Made it! At the top of hill and still smiling. Not sure about the band; I think they must be on oxygen somewhere. The hills in Baneswell are treacherous.

Autumn and Winter

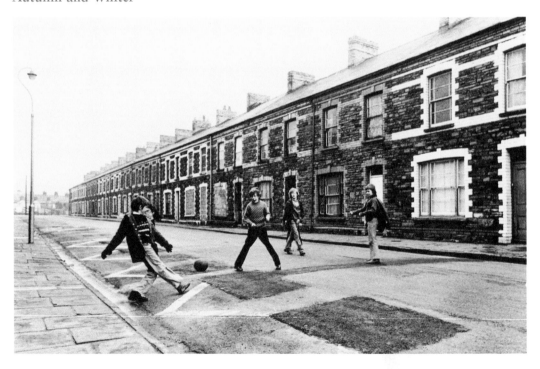

Cricket stumps, chalked on flat rendered walls, vanish slowly as the autumn rains wash the summer debris from the streets. Crumpled jackets, set precisely, become goalposts as another generation of Bobby Charltons, George Bests, and Kenny Dalglishs pull on their battered leather footy boots.

Right and below: Autumn's mists and fog were more severe when industry made its contribution. Who worried about health in the '70s when it was so much fun? So much atmosphere on the river that you can't see the shopping trolleys.

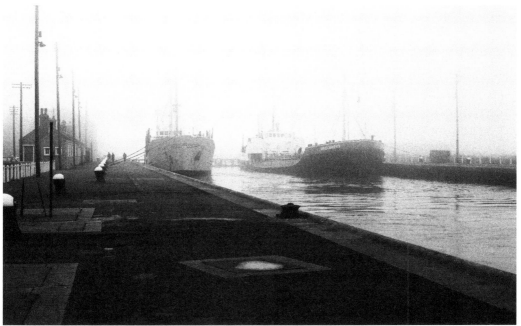

The Newport Show

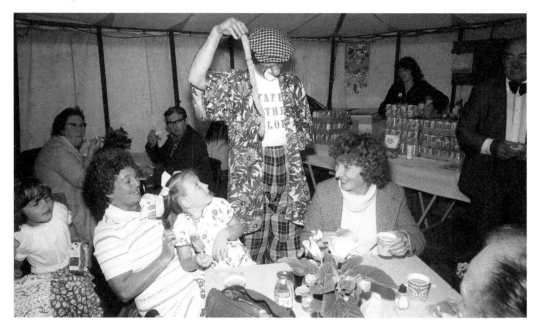

Classic traditional entertainment and not one iota of 'clown phobia' in the arena. That was the Newport Show. Newport has proud traditions in horticulture, and rightly so. The quality of the street displays and the beautiful parks are, in my and many others' opinion, second to none.

In the 1980s, it was decided to bring the talents and crafts of the local growers together and at the same time highlight the town as it was then, through the medium of the Newport Show.

Tredegar House and Country Park was the most appropriate venue for the growers, trade stalls and entertainment. It was homespun, it was local, it had a tremendous feel-good factor, it was Newport. In each tent, there was a homely warmth, possibly because it was the first show of its era but more likely because it was Newport folk at their very best.

You Make Me Want to Shout

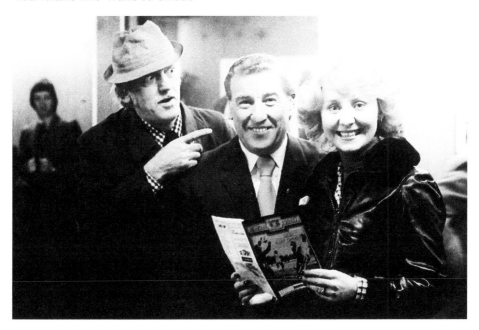

It was a bitter-sweet experience being club photographer to Newport County AFC. The constant highs and lows, the annual survival battle, waiting for the voting to see if we could remain in the football league.

Here, on one of the happier occasions, we see a visit to the vice president's lounge from singer and entertainer Lulu and Welsh actor and musician Stan Stennett. A half-time picture opportunity shows them both with the then chairman, car dealer Cyril Rodgers.

The autumn saw the start of the new football season and once again the long-suffering supporters of Newport County AFC could be guaranteed a roller-coaster ride of emotion. The 1970s were a mixture of extreme highs and equally plummeting lows. Survival battles, great escapes and high tension as the club fought to retain its league status. I was club photographer to the County for twelve seasons, and I must say they were very happy times. Newport County and their band of regular hardcore supporters were family. In the early 1980s, they achieved a remarkable change of fortune. Winning the Welsh Cup, appearing in Europe and gaining promotion to the third division.

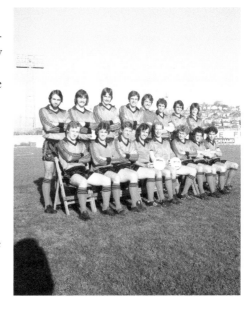

Parks

Looking back over the decades at Newport, what announced it as a place to be and love are Newport's parks. They have always been a constant and an immense credit to the town and city as it is now.

This autumnal 1980s view of Belle Vue Park and the greenhouses are a reminder of the annual ritual much loved by the children who, bobble-hatted, scarfed, and gloved, kicked the fallen leaves that were often deeper than their little wellies!

The distant view of the city from the Usk Valley, in November 1979, was enhanced from being on the Old Road, as opposed to the M4 to the immediate left. There is something about the autumn that says, quite clearly, carry a camera.

Light Up the Sky with Standard Fireworks

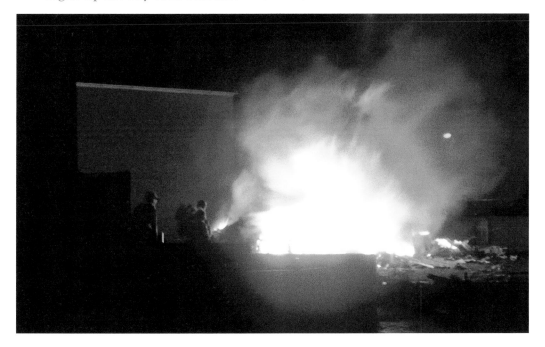

Light up the sky with standard fireworks, as the advertisement told us. Alternatively, it could have been Astra, Paines, Brocks or Wells fireworks, all regular names for the 5 November in the '60s and '70s. Bonfire night was an incredible exercise in how not to burn down one's street. In the 1960s and the preceding years, when the terraced street ruled supreme, the only place to make the fire was in the middle of the street at the crossroads. For the kids, it was pyromaniac heaven. As for the adults, what a great way to be rid of the old sofa or bed! The whereabouts of the stashed combustibles were a closely guarded secret. A slip of the tongue and the next street would have them away in the flash of a banger!

The bonfire was higher than the eaves. The guy, resting precariously aloft, would be short-lived as the masses of paper and wood erupted in flame. Paint dripped from the adjacent houses, the road surface melted into oblivion, and the fire brigade rattled around the town, putting their skills to the test while everyone else had a grand time. It was a rare phenomenon indeed. The family were in the street enjoying the rockets. Father oversaw the firework tin, an ex-biscuit barrel, and a jack-in-the-box finale was being set up on the pavement. We always kept the best until last. Another triumph as the final bang sent the burning iron filings into the air. That was it for another year, or at least until the morning when the customary search for the unexploded took place. But was it? Surely the small blue flames appearing along the cracks in the pavement didn't come as a freebie from the firework company? That year we had a small methane problem, all very pretty but the gas company were not impressed.

In the Bleak Midwinter

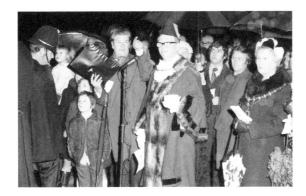

'The camera is that way Mr Mayor'. The year 1974 and the Mayor of Newport, Councillor John Marsh, leads the singing as the tree, which was on that occasion positioned on 'Gilligan's Island', Cardiff Road, was illuminated. The torrential rain did not dampen the spirits of those gathered. Being a Christmas-file, it is quite easy to be carried away by this special time of the year. Unsurprisingly I am not alone in sharing this sentiment as many, especially those with small children, can happily fall headlong into December with joy.

Memories of Christmas are a personal delight – we all have touchstones – and in preparing *Now That's What I Call Newport* I rediscovered many that I could share. The shops both small and large seize the moment as the first trappings of festive colour appear in the windows. Newspapers and magazines bulge with extra pages of advertising, while interesting things appear on the fruit and veg stalls. Chestnuts, pomegranate, and satsumas create that special aroma found only in December. At the beginning of the festivities the town held an annual open-air carol service to celebrate the turning on of the lights.

In later years the ceremony became more centralised. Gilligan's Island is a small grass area midway between the docks and the centre. It was created when the Salutation Inn was demolished. In '74 it was the venue for the carol service.

In the 1960s greetings and gift tags were still printed in the traditional manner. Foil and its unpleasant tardiness was yet to appear.

A Christmas Carrot

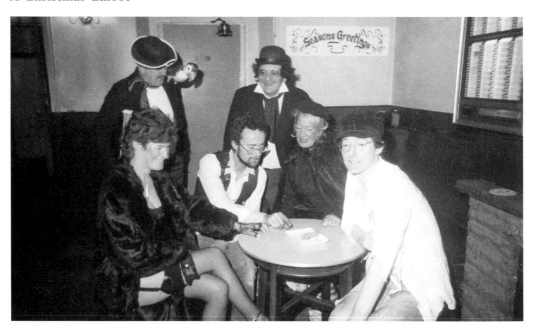

While many adhere to the festive sentiment, others opt to do the outrageous. Here at the Engineers Arms, the regulars dress rehearse *The Christmas Carrot*, a community play not for the faint-hearted or those presuming to be intelligent.

Pictured are the 'Scratch it Family' staring at their last penny piece, featuring. Bernard Lovett, Tony Roberts, Morag Hart, Diane Boswell (Landlady), Bob Simms and Stephen John Poet Williams.

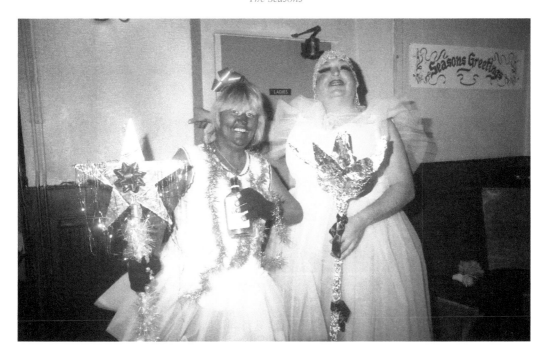

Elegance personified by the two good fairies: (left) Anne Gribble and Roger Boswell (landlord). With the main dressing rooms situated in the gents' toilet and a video link between the three bars, this successful once-only performance was so oversubscribed that the directors from the brewery failed to get into their own pub.

Most of us will have a memory based on the snow, remembering when the snow was so deep, and how we coped with the frozen wastes. While white winters have become more unusual there are many memorable years that none of us will forget.

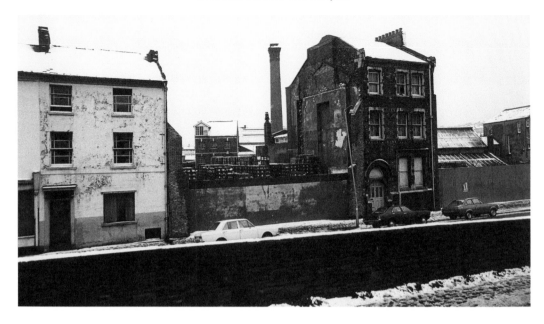

Boarded-up houses and the remnants of a snowstorm is not a pretty sight, however. On the same day in 1977, the old Dock Street Post Office and the Courage bottling plant still say there is something of the old Newport still going strong.

Festive Snow

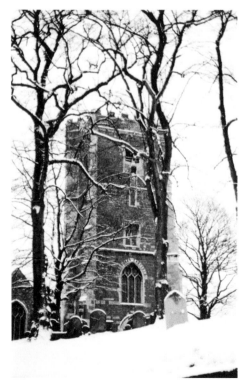

If only every Christmas was like this one in 1981, which is a perfect setting for Newport's St Woolos Cathederal. There is something very special about the Christmas carol service at the cathedral when the snow is falling.

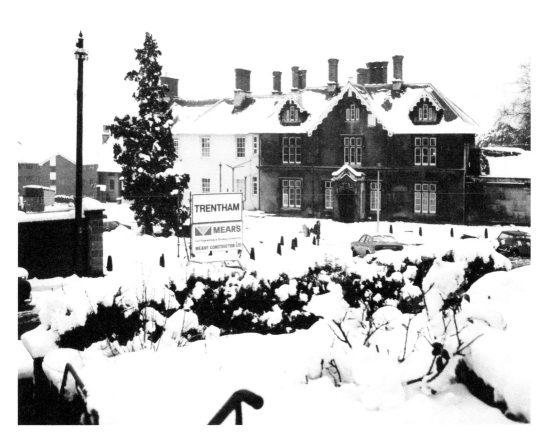

The White Friars of the Carmelite order used to live in the Friars. A series of celebrated Newportonians followed including Octavius Morgan and James Prothero, who was the town clerk. Now it is an administrative centre for the Royal Gwent Hospital. It is one of the few remaining buidlings in Newport that has true historic lineage and is still standing. Pictured in 1979, it offers a picturesque insight of Newport at its best. Many of the adjacent properties in Friars Road have quantities of ancient apple and pear trees, a remnant of its days as the home of the White Friars.

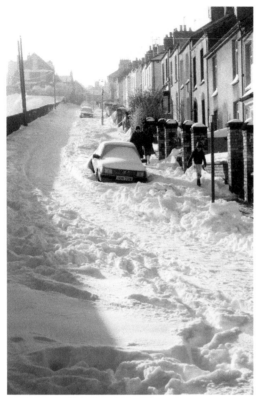

One of the worst winters in recent years was that of 1981, when temperatures plummeted to minus 17 degrees and the town was at a standstill. This is tunnel terrace and it is worth mentioning that the first pathway cut through the deep drifts was to the pub.

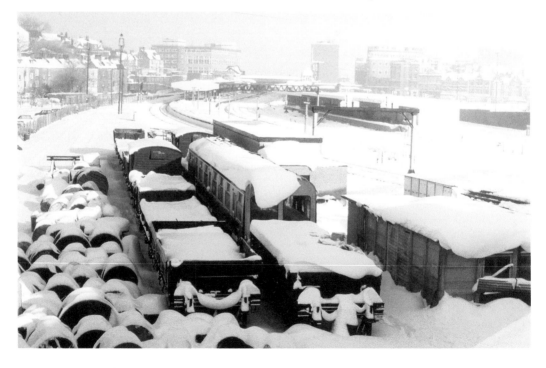

Newport station from Godfrey Road. To the credit of the railwaymen, the trains still ran.

CELEBRITIES COME TO TOWN

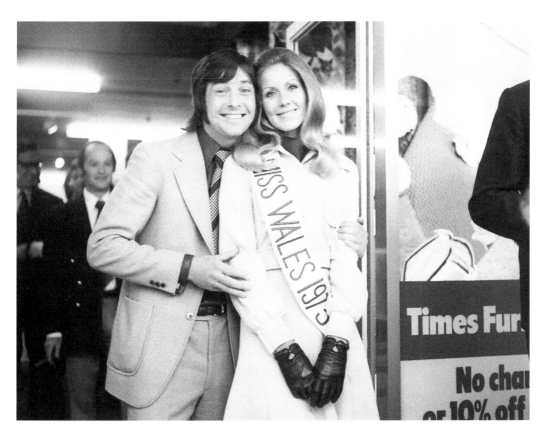

In the current era, when the High Street is under threat from the Internet, celebrities opening shops is becoming increasingly rare. Wales rugby start Barry John and Miss Wales 1973, Jennifer Greenland, pose at the opening of the Times Furniture store in Commercial Street.

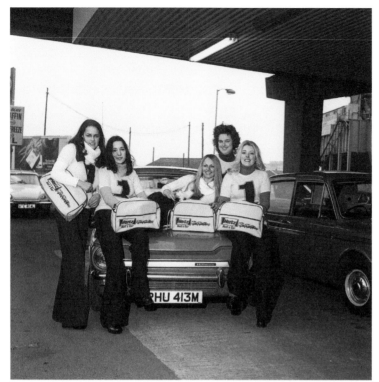

Meanwhile at the Kingsway Service Station a group of lovely ladies promote the Hertz Car hire company. In the background is a glimpse of the Sessions sand wharf, on the banks of the river, which you might prefer to look at depending on your age!

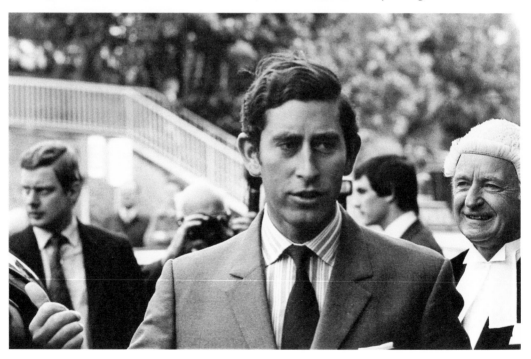

HRH Charles, Prince of Wales, arrives at the Civic Centre, Newport. This was taken in the early 1970s on an official visit, just a few years after his investiture.

Royal watchers were out in force lining the grassy banks at the main entrance, which is at the rear of the building, braving the weather judging by the headscarves and raincoats. Cameras are at the ready – another good day for Kodak.

History's Silver Screens

In the '60s and '70s there was a marked decline in Newport's cinemas. Multiscreen out-of-town complexes with car parking on hand took the place of the main street entertainment halls. The Odeon, the Capital, Olympia, the Coliseum and the Lyceum theatre fell out of favour. There was one building, however, that lasted throughout, not as a cinema though, completely intact but for an audience, films and a few little lodgers that bit at the parts nothing else could reach. This was the Tivoli Cinema. It was in Potter Street directly behind the Plaza, itself a much-enjoyed venue that closed in the late 1950s. For many years it was the home of a light engineering company, many not realising that a small part of Newport's cinema heritage was on their doorstep.

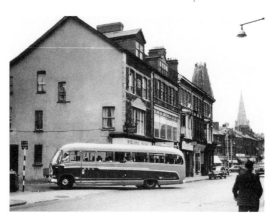

No amount of persuasion could save this historic corner of Newport. The Salutation, one of Newport's earliest pubs, could be found here, as could Dons, the oddment shop where one could see and enjoy a most incredible range of curiosities, buy books by the yard, watches, guns, toys, trains, tools – you name it, Dons would have it for sale somewhere in the darkened emporium. However, perhaps the most missed of all is the Pell's sweet shop. The most divine smell of hot sweet mints and fruity boilings would engulf you as you walked past the shop or behind, in what was known as Pell's Lane. It was a sensual wrap of happiness, an imaginary big sugary hand to which one surrendered with happiness. History is never far away though. A little-known fact is that here, on the site of the car park that the coach is about to enter, was a fairground. Dodgems, children's rides and a rifle range were reportedly there.

The Green Stamp

I am quite sure that the people who created the Green Trading Stamp also created Pokémon as a retirement fund. Such was the fervour surrounding these little adhesive scraps that it turned vicars into scallywags, lorry drivers into arch criminals and the housewife into somewhere between Mata Hari and the Kray twins.

At its pinnacle, the Green Stamp became an icon, though a gateway into nowhere. For when sufficient books were filled, the shiny Ford Anglia, in showroom glory, became a myth.

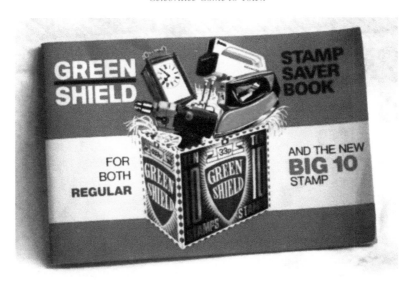

Life became a dangerous occupation should one grab someone else's stamps. The era of the Green Stamp ended in 1991 with little chance of a revival. The Green Stamp has had its gum licked for the last time, but what of a comeback? Having survived the era, how good would it be to sit back and see a people battle for them just once more?

Perhaps the greatest story is of the lorry driver who had purchased many gallons of fuel from the garage, only to be told he was not getting his stamps. At the till he had other plans. However, unmoved by the refusal, the driver proceeded to release over 150 gallons of fuel onto the forecourt. Never were stamps dispensed with such vigour, by so few.

Sitting Around

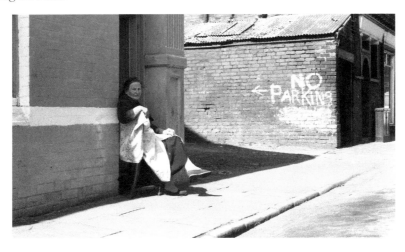

Do we really need the great information highway, newsrooms and newspapers? Of course not. In the day, we sat on the doorstep, and if there was anything worth knowing, we would soon hear of it.

A quiet news day in New Street in 1977. The bulldozers had not reached this part of the neighbourhood yet. To whom is the no parking sign referring? If it is the good lady from the end house, it's a bit late as she is already clocked.

A street history could often be seen in the colours of the telegraph poles, and street parties, coronations and investitures were often reflected by the painting of the street furnisher. Blue and white hoops, I wonder?

More sitting about, this time in 1974. Grandad got the news presenters' chair, while a guitar is found to add a song to the obvious celebrations. The piano was a bit heavy to get over the doorstep so he gave us a bit of Elvis instead.

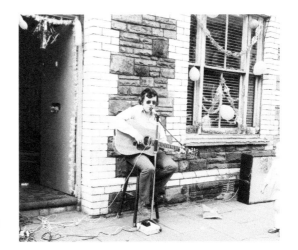

The images were taken during the 1974 Pill Festival – community action at its best as everyone played a part.

A Fish Supper

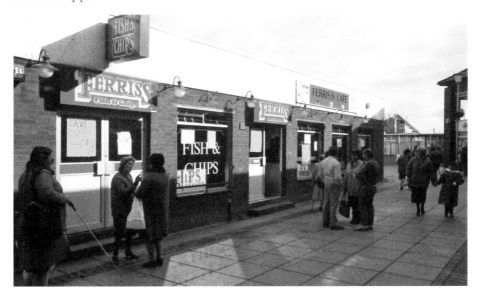

After any good night out, there was only one route home, and that was via the chippy. There were many chip shops in Newport. They never sold kebabs, or curry or burgers, just good old-fashioned soul food – fish and chips or pie and chips. That was that. Cod or Hake was the norm, and pies and pasties varied, but there were some that stood the test of time and that was Clarkes Pies. An oval handful of steaming hot meat and gravy, thick pastry for holding, but the filling still managed to break free and run down between the fingers. That was called gastro pain.

The Ferris family are one of Newport's oldest and best-known café owners. In the 1950s, they owned the Mexican Café in Griffin Street, opposite the provisions market. Until recently they ran a highly successful café in Dock Street adjacent to the bus station (pictured above). There were prerequisites for the best fish and chips, one of which was to be cooked in dripping, the other was to sell the 'scrumps', delicious bits of batter and fish that had fallen off the cutlet and were collected off the fryer.

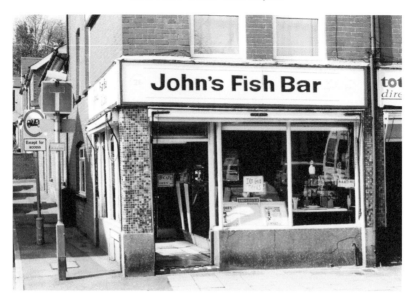

Each area has their favourite chippy: Cueto's Conti's, Shepperd's, and Chave's to name just four. However, the one that I found extra special was John's Fish Bar on Cardiff Road. Sadly retired now, John's crossed the decades and never faltered in quality or service.

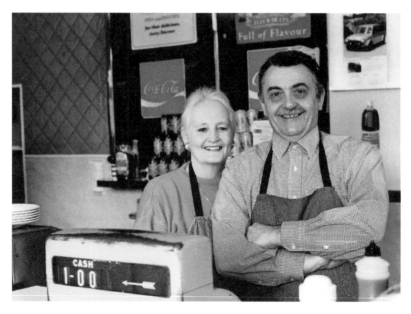

In the early 1960s John's was the ultimate treat. A film at the Capital Cinema and a fish and chip supper. The real chippies had tables and chairs to sit down and eat in, or you could take away. That was just part of the deal. Bread and butter and a pot of tea put the icing on the cake, or the salt on the chips, whichever you prefer. What made this small café stand out was not only the service but the fantastic art deco range in which they were cooked.

Can you get any more traditional than this art deco range? As I child I shared this vision, and as a father I offered the same to my children, who were all more than happy to eat at John's.

The Newport Cattle Market
In the 1960s people still lived by a routine: Friday and Saturday, they visited the provision market and Wednesday in Newport was cattle market day. Domestic life carried on in the same vain; the same meals were often eaten on the same days as were the tasks of washing and cleaning.

Meanwhile, on the edge of humanity as we knew it, the cattle trains were arriving at Dock Street station. Prime cuts still wearing their fur lined up in the lime-stained pens waiting to be herded to the adjoining cattle market. It was the same every Wednesday as the beast walked through the street from the station to the auctioneers, from where they were dispatched, or in most cases dispensed.

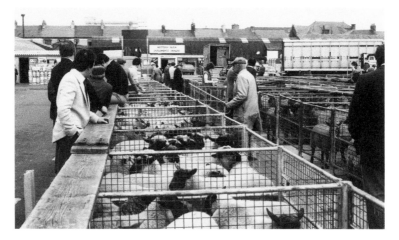

Among every tribe on the planet there will be one at least who is a born survivor, whether it be the animal or human world. So occasionally while en route to the other side, sensing its inevitable fate, a large four-legged beast would cut loose and run like fury through the terraced maze of streets. This was utopia, the Wild West delivered to the doorstep. Better than Alan Ladd and John Wayne combined as the kids from every corner joined in the mayhem, whooping and chasing the hapless grass-fed animal in a vain bid to incarcerate it and see it turned into corned beef along with its cud-chewing compatriots.

Yes, all good on paper, and the boys from Dead Man's Creek were on the move again. Head it off at the pass, cut it off twixt Esso Blue Paraffin and the Ginger Nut shop. As the posse of juvenile cowhands raced in pursuit, the beast made a life-changing decision and turned into one of the numerous terraced houses, only to face a family eating their Wednesday pie, beans and chips.

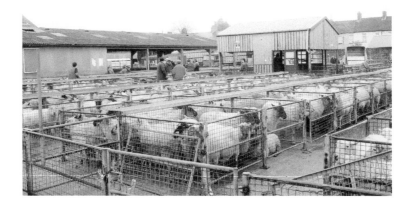

Overcome with acute vapours, Grannie launched a short-crust grenade at the rampant herbivore. Meanwhile the others, who were once sitting quietly enjoying their food, shouted and screamed while the beast demolished the kitchen. What better way to spend one's lunch hour than in the eccentric highways of Newport eating pie, beans and chips watching Grannie engaged in a bullfight.

The Pill Police Station

Suitably placed near to the main entrance to the Alexandra Dock, the Pill police station is a fascinating building with many late Victorian features, including the cell block equipped with spectacular cast-iron toilets and cisterns. When it finally closed in the 1980s a local heritage group, assisted by the building's new owners, endeavoured to turn it into a community facility, including childcare, a local museum and a small puppet theatre for the benefit of disabled children, who could not enter the world of creative art and theatre owing to their disablilty. Immediately the plan was dashed because of its unsuitability due to parking. The police never needed parking? Perhaps they used horses. It remained empty for a short period and then reopened in its new community-friendly identity as a massage parlour!

The Sheppard Building

We often take our heritage for granted and we never realise its value until it is gone. Newport's streets were awash with strange-looking buildings, often seemingly out of character, and used for entirely different purposes than those they were originally intended. This incredible building, once found in Temple Street, was in the late 1800s Pill's police station. In addition, it acted as the mortuary and housed the fire engine. When demolished in the 1970s it was used as a furniture restorer's. People opened the same door and looked out of the same windows as they might have done 100 years earlier. It's strange, thought it's provoking, it's Newport.

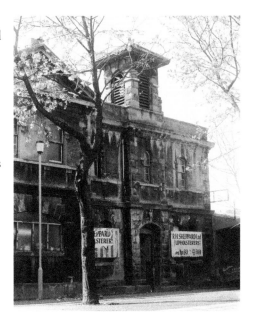

The Waterloo Hotel

The final frontier in Newport, where the houses end. Even today, looking at the most impressive façade of the Waterloo, one cannot help but feel just a very small part of an incredible history. A busy duel carriageway and a tall perimeter fence now stands between the Waterloo, the docks and the River Usk. 'Happy to report Sir, that all of the Urban Historians armed with cameras, pencils, notebooks and available historic data have now been contained within the stockade'.

The Waterloo, notably the most famous pub in the city, began life in the late 1800s. It had one of the longest bars in Britain. Lined throughout with glazed ceramics, I feel that the builders knew that it was destined for greater things. It had high ceilings, rooms for eating, sleeping and transacting. The dockers at one point were paid out in the Waterloo, a clever stroke of ingenuity indeed. In the '70s it became the Gatsby but was always known as the Waterloo.

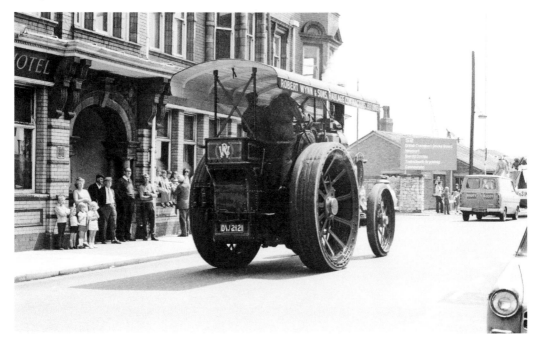

An unusual visitor passes the Waterloo in 1975. The docks entrance with police box stands in the distant centre of the image.

The Pill Fairies, who came out once a year on 25 December in search of a Scotch Pine, were a friendly group of maidens, and were frequent visitors to the famous hostelry. Never without a good deed in mind, they performed many magnanimous acts of kindness in welcome to the numerous seafarers who graced our shores via the Alexandra Docks.

During the war years it is said that the bars were so full of servicemen that a postage stamp would not get in. Our merchant seafarers found solace and hope from the red-brick clock tower that stands on the corner of the building. It is said that when the tower came into sight they were free from the threat of the U-boats, which often lay in the Channel in search of another kill. Now after many years of mixed fortunes and a complete change of ownership and direction, it is a well-situated hotel and bistro. It does still happily carry the name and the heritage of the Waterloo Hotel.

Iron Gate Crossing

It is rare nowadays to find a level crossing in the heart of a city, unless of course it is adjacent to a railway station (I refuse to call it a train station. This is Newport not New York!) Here in Commercial Road, the railway line crossed at four points at some time in history. The principle crossings were referred to, as the first or second iron gates. Here are the first, this was the start of the neutral mile, which was a stretch of line between two different railway companies. Here the line originally ran from the Western Valley, via Newport's first and temporary station at Courtybella, to Dock Street, which was for a time the principle station of the town.

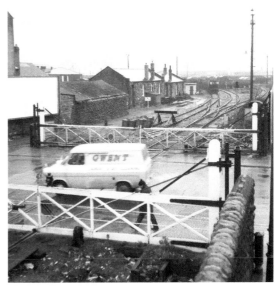

The large double gates were destined to survive until the end of the line – the best-laid plans of mice and men! In the 1980s a rather large class 37 Diesel Electric locomotive had a hissy fit and took one of them clean off its hinges. Oh dear, oh dear, the Old Mon, as it was known, had a black eye, and it never really recovered. The crossing was for some years protected by men with flags as it still served a coal distribution point, until the cobble and nutty slack became non-PC, and the whole trackbed was turned into a road.

Sunday School at Alma Street Baptist

Mum smiles inanely as she waves at her offspring, disappearing into the distant maze of streets. Small people clutch their children's bible walking the walk, the Sunday afternoon procession to learn the word of the Lord. Dad, meanwhile, is down to his hobnails in wait for his desirable other half. Sunday special time is a well-deserved rest from the kinder, to do what one likes best, to relax.

This classic Sunday school image, barely changed since the Victorian era, was to be found at the rear of Alma Street Baptist. A Parkray or perhaps a Rayburn stood where the coal fire once burned and 1960s-style tubular metal seats replaced the aging wooden desks and chairs.

It was here that we sat and listened in fear to the promise of hellfire and damnation should we stray from the straight and narrow. When we had finished, after a prayer and a few more words of spiritual guidance, we made our way home.

Dad was in the garden, pottering happily with his geraniums while Mum spread the butter on the tea-time bread, still wearing the inscrutable smile seen only on Sunday school afternoons. We had all benefited from our hour out, and whatever we chose to remember from those days, or believe in, it is still a good set of guidelines to follow.

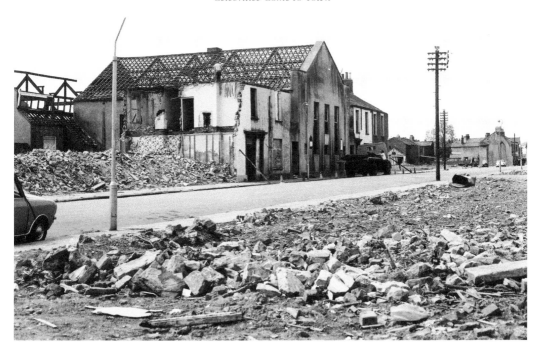

Nearly derelict and standing alone, Alma Street Baptist Chapel crumbles into oblivion. The new church opposite in Kirby Street opened soon after.

Holy Trinity was the sister church to St Stephen's. It was demolished in the mid-1970s in favour of sheltered accomodation for the eldery. Meanwhile St Stephen's continues to thrive, albeit with fewer bums on seats these days.

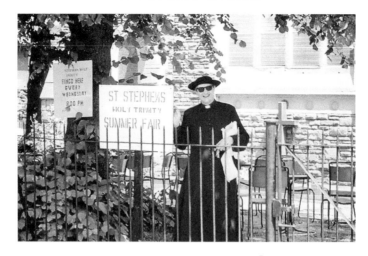

Father David Nicholson was a characterful priest unlike anything that came before or after. His flamboyant style and personalised interaction with his flock ensured that the Church of St Stephen prospered and thrived under his leadership. Here pictured looking exceedingly papal he is seen at the opening of the St Stephens summer fête.

Father David was a man of the people and was never afraid to knock the door when needed, or pay a hospitality visit while passing.

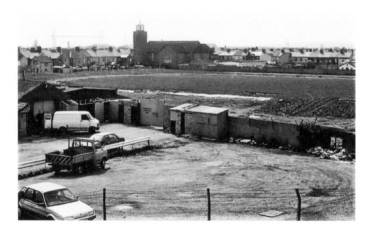

Legendry in so many ways, Somerton Park was the home of Newport County AFC. It saw the many ups and downs of the famous Monmouthshire Club, but in 1989 could not win the battle against redevelopment. It is now a housing estate. Somerton also hosted Newport Speedway, which was never popular owing to the damage to the corners and touchlines of the pitch. Without Somerton and league status, they became the Exiles and played there games in Moreton-in-Marsh, Gloucestershire. Fortunately, their name Newport County was legally retained and having regained a place in the football league, they now play once more as Newport County.

Newport County had much to celebrate in 1981 after gaining promotion, winning the Welsh Cup, and having a good European run. The open-top bus parade was a must and being on the team bus exposed a new look at many old architectural favourites.

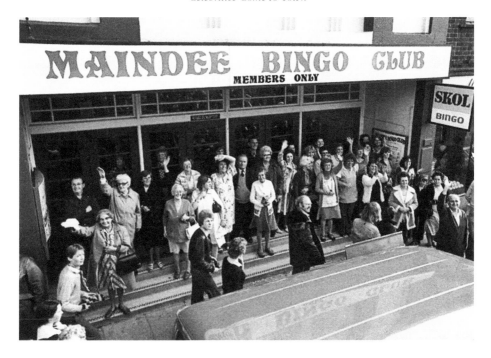

Maindee Bingo Hall used to be the Maindee Cinema. The parade started at Somerton Park before ending at the civic centre for a formal reception.

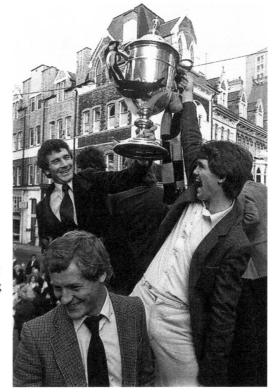

Dave Gwyther holds the Welsh Cup aloft, while striker Tommy Tynan (front) can't stop smiling at the huge cheering crowds showing their appreciation for the season's mammoth effort. Tommy, who started his carreer at Liverpool, went on to have a highly succesul career with Plymouth, and is still respected as a player to this day.

SOME CHARACTERS OF THE '80S

Eyes Right

Not much evidence these days of the Royal Horse Artillery in town. However, for many years the Gunners Club in Marion Street was their social home. Pictured are the Gunners Ladies Committee along with a khaki-clad driver of the regiment waiting to take them on a jolly. To the right of the picture is the formidable Mrs Cook whose purpose was to promote the regiment and its memory at all levels. Her husband served in India up until independence in 1948 and took part in a parade in front of the viceroy.

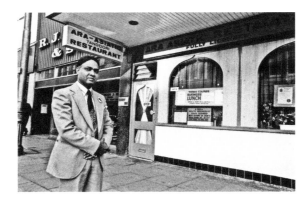

Mr Jabber was the owner of the Ara Asiatic restaurant. He was a socially minded man who frequently entertained the great and the good in the upper half of the restaurant, and served the real McCoy in terms of authentic Asian grub. The Ara Asiatic was a post-match hang-out for many of the Newport County staff and press. Here we hid pretending to talk football while drinking lager or Mr Jabber's dreadful, powdered restaurant tea, from a machine with even more powder in the form of milk. It was just the right starting point for a good Saturday night out. Thank you Mr Jabber.

Thank Heavens for Sundays.

We often say thank God its Friday as the weariness of the working week descends upon us. In 1972 Poet Laureate Sir John Betjeman declared a similar emotion as he presented his wonderful documentary *Thank God, Its Sunday*. His compelling view of the Sunday community, as it went about Sunday life, doing Sunday things, is a captivating look at what we do on that once special day.

 '70s Sundays, for many, began with the banging of the boots, the forgotten caked mud clinging to the studs as the footy boots were brought from the car, where they had remained forgotten since the previous week's soggy excursion to the park, 90 minutes of hung-over huffing and puffing trying to find the back of the yellowing nets.

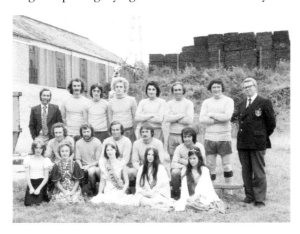

90 minutes when one could become a Kenny Dalglish or a George Best. Playing against the YMCA in the Carnival, on the home ground, sweat, mud and beer equalled happiness for the sporting man.

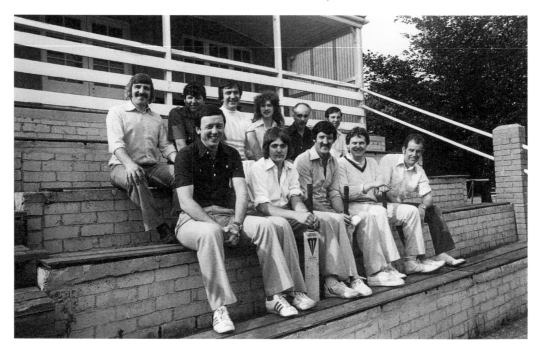

Most of the larger industries had their own sports clubs. Taken in 1981, this is the British Steel Corporation cricket team, playing at Panteg.

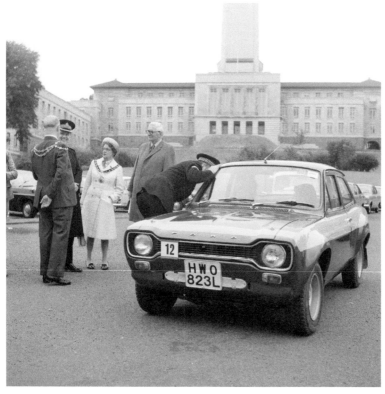

Leather seats and nodding dogs, vanity mirrors gleaming, a small perfumed effigy of a duck or a rabbit swings from the mirror, wafting nasal pleasantries onto the occupants of the 1960s Wolseley 4/44 or this classic Escort.

Not today the burning of the rubber, the handbrake spin, or the skipping of a red light. Road safety and exemplary driving was the order of the day. Sgt Williams of Gwent Police was our road safety Officer. His safety and good driving programmes attracted the best that motoring could offer. With pride and passion, they rallied and manoeuvred against each other for the prize: a prestigious trip to the council chambers for a trophy and a hearty 'well done'.

Penhow Jalopy Racing Club

As the roasting joint bubbles quietly in the pan, and the gravy boat makes its weekly outing from dresser to dining table, a roar from a distant field gathers in intensity. Bales of straw litter the arena, and Sunday men with printed armbands direct, organise and wave arms. Some carry flags, others have protruding fingers with which to point, and some hold containers for cash.

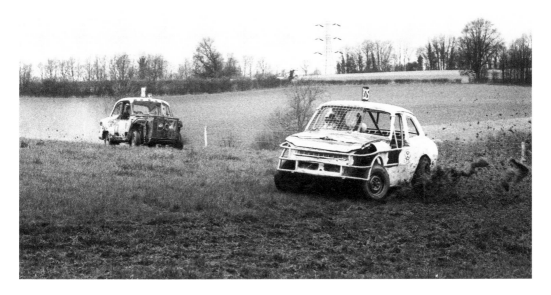

The smell of raw fuel and burnt oil permeated the nostrils. Portable welding plants flicker into life, and strange components, anti-roll bars, grills, mesh, and armoured hoses are speedily shaped and reformed prior to the next race, scenes to make the scrap man leap with glee, as the battered Ford Cortina, the Anglia, the Hillman and all else with a chassis are reclaimed by the relentless enthusiast.

Penhow Jalopy Racing is not a sport for the meek. There were collisions to make the strongest men and women cringe. Could one imagine a better way to spend a '70s Sunday?

The smell of burnt fuel, grease and oily mud is not for all. Newport catered for many other sports one of which was lawn tennis. Real grass, well maintained to tournament standards, was a luxury. The Newport High School Old Boys Lawn Tennis Club was and still is a first-class institution in the 1970s, when this image was taken. It not only had an excellent tennis section, but a vibrant social arm that did much to support the club. Newport was also the venue for the Green Shield Tournament, which is held annually at the Newport Athletics Club. Pictured are the winning quiz team, which on that occasion was hosted by quizmaster Mr Tony Taylor.

Steaming Ahead

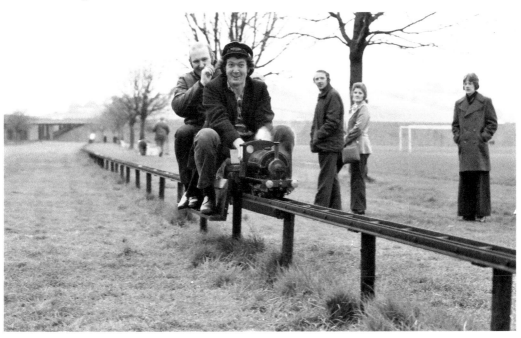

Can anyone better this for a Sunday activity? The skill required to build one of these fine steam locomotives is enviable, and to create such a piece of engineering that will carry passengers is even more outstanding. This was fun at the Glebelands 1970s style. The good news is that Newport Model Engineering Society are still steaming.

MUSIC AND ENTERTAINMENT

The arts have always been the jewel in Newport's crown, whether it be music, fine arts or acting. Is it something about dockland towns and cities that spawn fine musicians and actors, I wonder? Part of the annual cycle has always been the pantomime, which was performed at the Lyceum Theatre, a building of some magnificence, or the Little Theatre/Dolman Theatre in Dock Street. In addition to the annual popular event one could enjoy a musical or a review.

Miss Rita Page (pictured) had many roles in pantomime. She performed and directed and brought much to the table in experience and knowledge. As anyone who had the pleasure of a conversation with her would undoubtably find out. She was in fact one of the few remaining music hall acts who performed in and could remember the real old palaces of entertainment. Her last professional venue was in Plymouth, after which she retired and moved into local theatre.

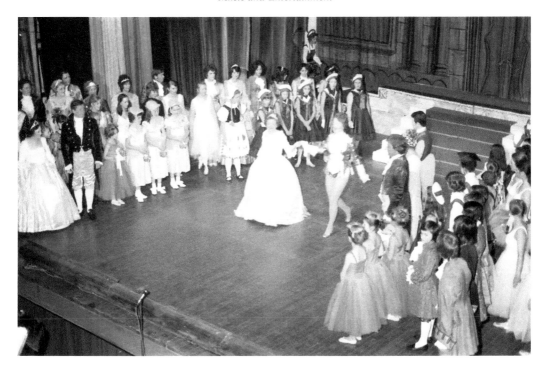

The 1974 Newport pantomime at the Dolman Theatre in Kingsway. Newport once had a number of theatres, including the Empire, the Pavillion, the Lyceum, the Dolman, the Pavillion and the Little Theatre. The present society was started by Rita Page, Terry Underwood and Bill Robins.

Hard work and dedication is required to belong to any Pantomime group or musical society. Run by volunteers, the annual pantomime is still held at the Dolman Theatre while rehearsals and other activities are in their hall in Queens Hill.

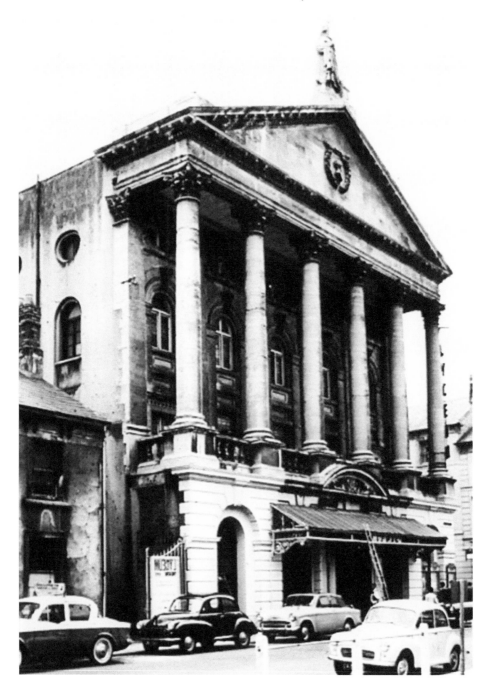

Theatre and panto was at one time held in the Lycum Theatre. The Lyceum was
Newport's greatest tradegy. The beautiful building was stately: it had glass carriage
canopies over the entrance and high columns supporting a massive ornate stone
jetty that formed part of the roof. It would not have been out of place in the
'West End'. It was demolished and the most vulgar red-brick and concrete cinema
and car park was built in its place.

In my community it was difficult to avoid music. We grew up to the backdrop of a rich musical legacy of jazz, swing and the big band sounds of the war years. Traditional music hall melodies of the First World War were still commonplace and happily aired on every Saturday night whenever a piano was found. If that wasn't enough to plant a seed of enthusiasm, the Salvation Army came and played under the bedroom window every Sunday morning. Old-time music halls were still a popular theme in the 1970s in both pantomime and musical societies.

For others it was more homespun, like these ladies taking part in an Easter bonnet competition.

As we moved into the 1960s a new phenomina was sweeping the country. Rock and roll and skiffle had arrived during the previous decade and had stayed. Now the swinging sixties were in progress and bands were appearing in every street in the area. The desire to emmulate and be a part of this incredible story was overwhelming. Walk along any Newport street in that period and one would hear a complete cross section of instruments spring to life. The front room sofa was relegated to the corner and drum sets appeared where the table once stood, while small combi amplifiers screeched out in competition to the infinitely louder sounds of the precussion section.

Alan Smith was borne in David Street, in Pillgwenlly, on the water's edge. As a child he bought records of Frankie Lane and Doris Day, and at every opportuniuty he sang. It was an obvious progression that he would soon team up with his brother Gerald, who was a piano payer. The two youngsters were soon offered an opportunity to appear in the James Street Labour Hall, in which they were an immediate success. Shortly afterwards as their popularity grew, they were joined by a young and dynamic drummer, Mark Goodwin, and became the Rikki Alan Trio.

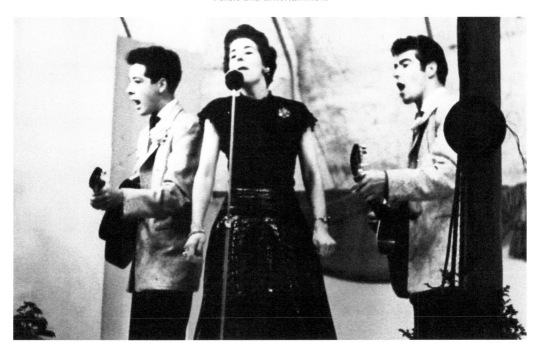

In the early days the brothers also sang with local singer Peggy Leclare, who founded a popular dance school. They are pictured here at the Newport Carnival.

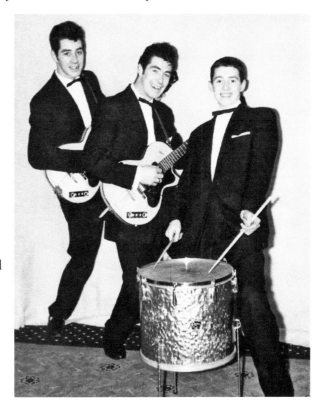

Rikki Alan, brother Gerald and drummer Mark Goodwin on Newport Turf before heading for London. The Interns made one final change to their set-up when they replaced their lead guitarist with the lead from Dusty Springfield's backing group.

The Rikki Alan Trio were soon to cut their first disc on the Decca label, while also making regular TV appearances on popular pop programmes such as *Ready Steady Go*. Their rapidly increasing popularity brought their pressence to the attention of the Tito Burns Agency, who suggested that promoters preferred four-piece bands. Whilst the boys preferred being a trio, they went with the flow and brought in a London-based guitarist, Mike Parker. From then on they became known as the Interns.

Like many other British bands the Interns followed the long trail to Hamburg, Germany, where they met and played alonside the great Jerry Lee Lewis among other notable artists. As the Interns they signed under the Phillips label and brought out the best-selling single 'Don't you Dare'.

Great Balls of Fire

The Interns were just one of many Newport bands who achieved success in the heady days of the 1960s. For the boys, the creative flame burns as brightly now as it did so many years ago. Alan and an active and talented group of musicians from that period can still be found playing in many venues in and around Newport, playing the same music that they loved, as we of that time loved, and is still sought-after today.

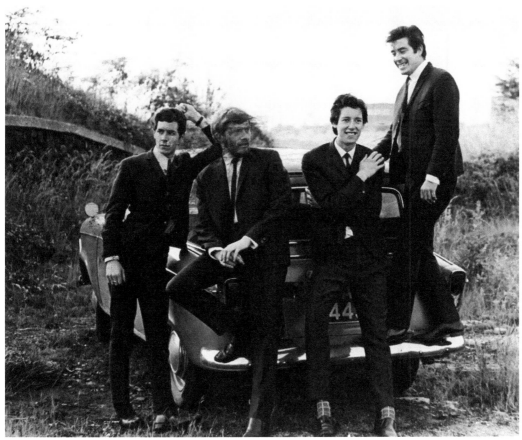

The Interns pictured on the dockside at Newport, fifty years on and a little older. The music and creative talent lives on.

Tiffanies

Newport has been the birthplace of a lot of talent, but for years it stayed in the shadows of other towns and cities and closed its pubs at 10.30 p.m. Many counties in Wales closed their drinking establishments completely on a Sunday. Those loyal to the felicitous pot would rush out of the Newport boundaries at 10.30 p.m. to grab that extra few drinks elsewhere.

In the '70s a club opened that proved to be the first of many in Newport. It was called Tiffanies and was situated in the centre at the junction of North Street and Baneswell Road. The idea and the theme was the Caribbean. Papier mâché palm trees and hoilday posters were suitably placed to create the holiday, care-free atmosphere. The cost of the drinks was definately off this planet compared to the normal pub.

Tiffanies was a special or weekend venue. It marked the start of a trend that continues today – loud, dark and costly.

TJ's Nightclub

I had the pleasure of interviewing John Sicolo on two occasions, and on each it was clearly evident that this ex-chief steward of the Merchant Navy was a man of many dimensions. John would always take a great interest in what one had to say, but on the flip side, his mind was always working overtime in persuit of new and exciting bands for his beloved club TJ's.

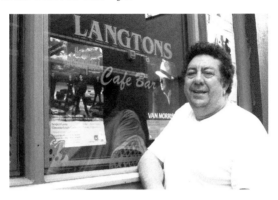

John Sicolo outside his other business – Langtons. TJ's was the end product of a number of smaller restaurants and bars in the centre of Newport. It was opened in 1985 and became a music venue that was soon to be known the world over. Many bands owed their careers to John Sicolo and TJ's, including bands that are now everday names such as Oasis, Manic Street Preachers, Stone Roses, Primal Scream and Iron Maiden. John passed away suddenly in 2010. He was a legend in rock music and he was 'Newport'.

The Kensington Club

Nightclubs are always at the mercy of the general public – noise being the operative word. The Kensington Club being situated in a residential area was always going to be an uphill battle because of noise, either in or outside of the club. It was an immensly popular venue for young people in the 1970s and many top-line acts appeared despite the constant protests from those living close by.

Top of the Pops favourites Pan's People danced at the Kensington Club to the tune of 'Doctor Love'.

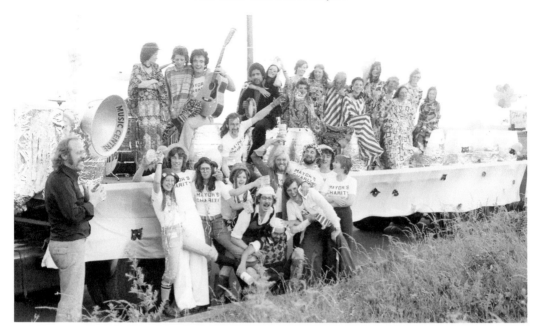

Kensington Club owners David and Marylin Blake with family at the opening following a major refurbishment. There were a lot of 'faces' at the Ken, which was the place to be. It was another great venue that was stamping Newport's name in the growing list of places where one could hear good music.

The Kensington Club was actually the Kensington Court Club and was situated in a large house in Kensington Place. Like TJ's it was no stranger to first-class bands including Status Quo, singer Dave Edmunds and rock band Brinsly Schwartz.

The Band was Just a Mist

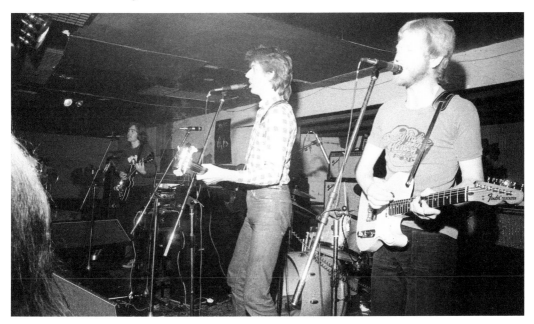

A thick blue tobacco haze makes it impossible for the flash to operate. To the photographer it was like driving in smog with the main beam. The flashing lights and ear-piercing music screaming from the speakers brings on an out-of-this-world sensation that only a good whisky will remedy. Brinsly Schwartz takes the stage, the dancing begins and the throat-raking smell of tobacco joins sweat and purfume in a heady essence labelled the Saturday night fragrance. The suspended wooden floor rises and falls slightly with each beat, adding vertigo to the growing list of symptons.

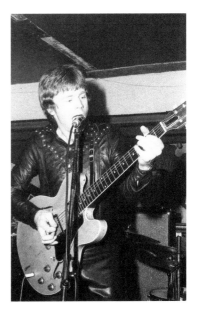

Singer Dave Berry at the Kensington Club, another act in a haze of sweat and tobacco smoke.

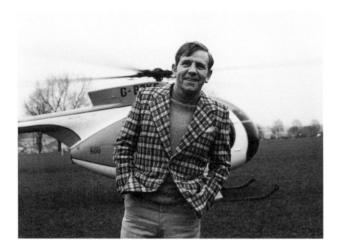

Helicopters are commonplace nowadays, but in the late 1970s the sight and sound of a landing helicopter would be sure to attract a crowd, and when this fellow steps out, a crowd is guaranteed.

Arriving in Shaftesbury Park for a show at the Hellmaen club is actor and commedian Norman Wisdom, wearing his characteristic jacket and adopting his trademark stance as he thrilled the waiting crowd.

The Hellmaen was a country club on the outskirts of Newport that specialised in high-quality international acts. Audiences came by coach such was its populariy. In the 1970s the club changed hands and the new owners, Messrs Truemans Brewery, continued to attract the best in entertainment.

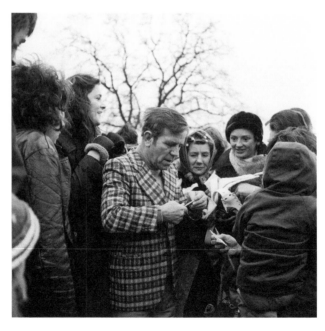

'Will he mind if I'm wearing my curlers Dorris?' I am sure he will be more than happy to see you in your curlers. But don't forget the lippy.

There are funny men, and there are extremely funny men, and there are men who reduce you to hysterics before they have opened their mouths. It is the latter that I pictured at the Hellmaen club in 1980.

'Ooh you are awful, but I like you'. It was a huge privelidge to work with the late Dick Emery, albeit just as a photographer for an hour's photoshoot. I had never seen an audience break into laughter when the act hadn't opened their mouths. Dick Emery was indeed the funniest man I had ever met.

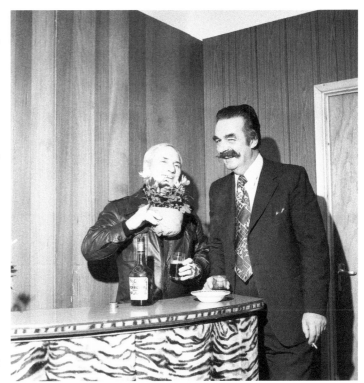

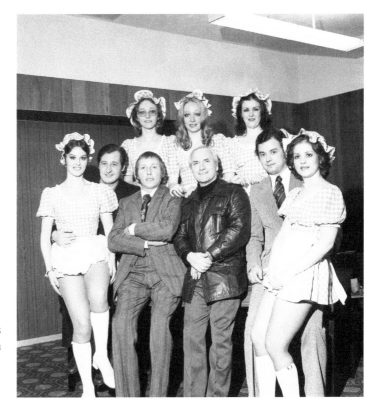

Dick Emmery and his supporting act, which was the unsuspecting public. Laughs were never far away.

The Engineers Arms

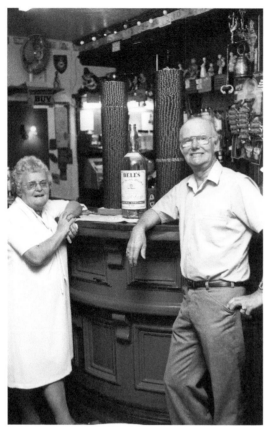

Until 1982/83, the Engineers was managed by Denis and Flo Reardon, whose welcome speciality was a first-class cooked dinner in the old style and the traditions of a working-class hostelry. One of their last acts as landlords prior to retirement was the Pile of Pennies competition. The 1970s and '80s were the last good years in the age of the Newport pub. The one-time small eighteenth-century market town with the massive population of beerhouses and inns was reaching its zenith. Social changes in entertainment, smoking habits and price rang the death knell to many of the city's finest hostelries. The dynasty of the traditional pub landlord was coming to an end; however, there was one pub, totally eclectic in structure, where dockers, artists, barristers, train drivers, solicitors, street sweepers, the unemployed, photographers, journalists and builders mixed happily under one crazy roof.

This was the Engineers Arms in the post-hanging basket period! It was a small street pub, on the junction of East Street and Tunnel Terrace that was in need of much love and attention. It had two traditional bars, a lounge, a snug and some dubious toilets. In a few short years Diane and Roger Boswell had transformed this small backstreet pub into a palace of fun and music. A resident jazz band, The Acme, played every Monday and on high days and holidays. In the lounge a baby grand piano took pride of place. It even had its own newspaper, *The Engineers Bugle*.

Diane and Roger Boswell, supported by a core of loyal staff, turned this small corner pub into Newport's most unusual and, to many, most popular pub.

Roger Boswell, landlord of the Engineers Arms.

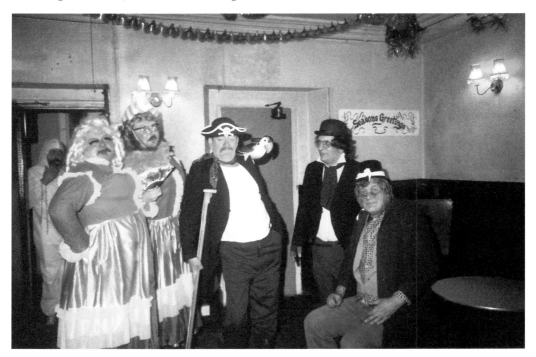

More from the Christmas Carrot: Bernard Lovett, Tony Roberts, Malcom Thomas and Ivor Hutton as they plead with Scrooge (Jan Preece) for another sniff of the sausage.

A Bridge Too Far

There had been a bridge on this site for over 100 years. Originally it was stone and the only means of crossing the new South Wales railway line. It stands adjacent to the road bridge at the top of Bridge Street and Clytha Park Road. It was a highly popular shortcut from Baneswell to the Civic Centre, in addition to the many thousands of drunks who had quietly pottered over it en route home. It was a godsend to mums with prams, hen-pecked husbands laden with the weekly shop and anyone who didn't wish to be seen. Sadly by the late 1980s it had become a grumpy bridge. A poor surface, equal amounts of rust and flaking paint left a huge question mark over its future. Refurbishment didn't really cut it and so it came down, in the middle of the night, aided and abetted by a huge mobile crane. Public opinion was strong and it was replaced by a modern structure.

Above and opposite below: The old deck was lifted off the abutments and placed on the other main road bridge for cutting up.

TOWN GHOST

Did this man see Mr Murenger? Pictured below in 1967 is Wynn's Heavy Haulage driver Gil French, of Fairoak Terrace, Maindee. Also shown is possibly Newport's oldest building, the Murenger House. The Murenger or the keeper of the keys was an ancient position that was held in the 1300s and related to the castle walls. A little poetic licence is required as to the precise age of this fine building, but around 1450 there was a building on this site. However, what is for sure is the authenticity of Mr Murenger, the 'Town Ghost', who does exist.

Not known for having a wild imagination, the driver who once stayed in the attic of the Murenger was awakened one night to see a man standing at the bottom of his bed. Mindful of theft, he challenged the person who he claimed was about to steal his wares. The figure dissapeared into the darkened corridor after receiving a suitably verbal farewell.

The next morning, feeling most irate, and considering the fact that he paid for his own room, he challenged the landlord, who instantly denied the presence of another human being in the upper stories at that time. Mr Murenger had paid a visit. Unbeknown to his lodger, the ghost had been seen many times both before and after the event, and today still makes untimely appearances. Is he or she standing next to you at the bar real?

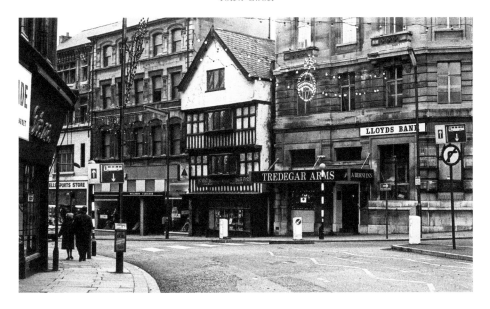

The home of the ghostly Mr Murenger, keeper of the keys. Be the last one to leave the pub, if you dare.

The Dudley Building

This odd-shaped wharehouse standing near Sessions Wharf has for decades been known as the Dudley Building. These were the premesis of Dudley & Sons, shopfitters, for many years, and are a a poignant reminder of the past. It was in 1974 that Mr Jo Dudley, a director of the company, asked me to photograph his award-winning Welsh black sheep. This I did and for some time I had the pleasure of capturing these fine animals on film. He invited me to the Royal Smithfield Agricultural show where he was exhibiting and went on to find success.

Winning at the Smithfield Show is a great achievement. The three things that illustrate it? They are happy, they are farmers and they are Welsh! (Mr Jo Dudley is second from left in white coat.)

St Woolos Church Hall

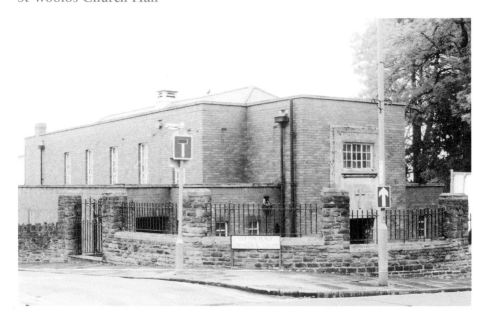

I am not sure if anyone could see the reason for demolishing this well-loved building. Anybody who has never been to a jumble sale in St Woolos Hall has definitely never lived. A certain professionalism in the real jumble hunter: never argue with a lady with a twinset in her sights; it might be the last thing you do.

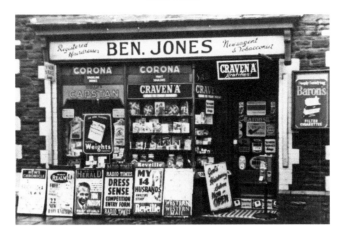

Every single thing about this shop urges me to get the time machine out of the garage. It is a registered hairdresser, newsagent and tobacconist all under one roof. A clean-up, a read and a smoke. What more could a body need?

Strange But True – Sort Of

For the final pictures in this book, I return to the bridge crossing the railway line from East Street to Tunnel Terrace, and offer a little-known account of the civil action taken when it was announced that the bridge would have to go. Pictured below are Bob Gribble and Mr Charles Farley, both at the time active members of the Engineers Arms' Baneswell Liberation Front. Dressed in Second World War bomber command garb, they patroled the bridge and the area adjacent to the Engineers Arms, in the event that the demolition crews might be dropped by parachute in the middle of the night. Local business donated batteries for their hand-held searchlights, while the staff from the Engineers provided sustinance.

Above left: They have spotted an invader!

Above right: This strange tale is probably very difficult to believe. Absolute rubbish one could say. Well yes of course it is total nonsense, they never used searchlights. However, as the title says, 'Now That's What I Call Newport' and I love every bit of it.

ACKNOWLEDGEMENTS

The majority of images contained in this book are from my personal collection, and are copyrighted. I would, however, like to thank Mr Duncan Brown for the use of his detailed images; Mr Alan Smith who kindly lent me his pictures of the Interns and also shared with me his story of his life in music; the late Miss Rita Page of the Newport Pantomime Society; the Pill Resourse Centre; Mr Doug Parker; and Mr Don Carter, Newport Family History Society. I apologise if I have forgotten anyone. It's an age thing.

Sunset over the old streets.